# Drawing Portraits for the Absolute Beginner

A Clear & Easy Guide to Successful Portrait Drawing

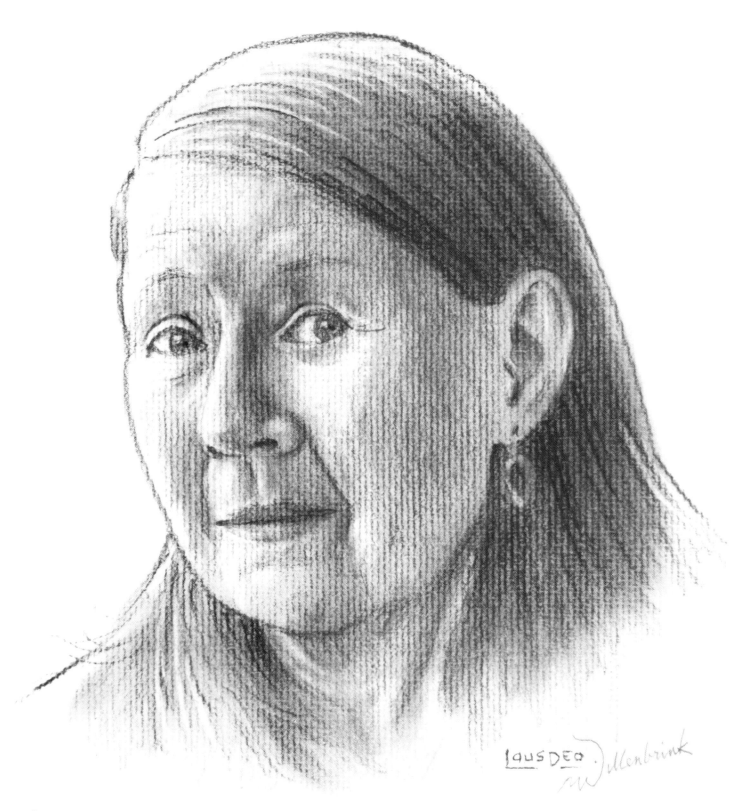

**Holly**
Charcoal pencil on drawing paper
12" × 9" (30cm × 23cm)

# drawing portraits for the

## absolute beginner

A Clear & Easy Guide to
Successful Portrait Drawing

Mark and Mary
**Willenbrink**

**NORTH LIGHT BOOKS**
CINCINNATI, OHIO
www.artistsnetwork.com

# Contents

# Introduction

We hope this book will have the same effect on you that it had on us—we fell in love with people. Drawing portraits offers the artist a unique opportunity to observe people. Every person is unique with their own special features and personality. Portrait art captures the personality of the subject through the eyes of the artist.

With simple tools and basic principles, this book will help you to develop your drawing skills. We will use some fun tricks and techniques to help you learn how to draw portraits, even if you are an absolute beginner. Everyone is an artist, including you, so get ready to have fun!

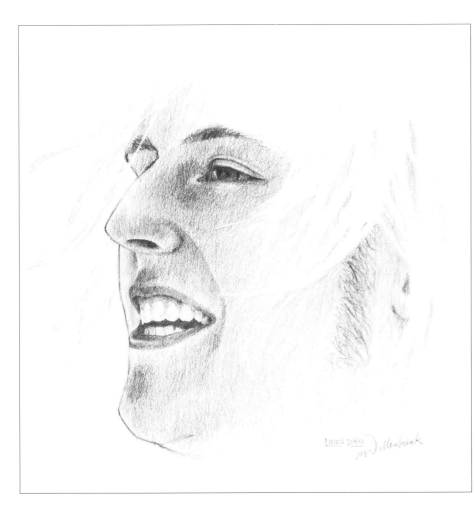

**B.P.**
Graphite on drawing paper
11" × 19" (28cm × 48cm)

## What You Need

**Paper**
9" × 12" (23cm × 30cm) fine-tooth drawing paper

9" × 12" (23cm × 30cm) medium-tooth drawing paper

9" × 12" (23cm × 30cm) light gray and medium gray medium-tooth drawing paper

9" × 12" (23cm × 30cm) sketch paper

**Pencils**
2B, 4B, 6B and 8B graphite pencils

2B charcoal pencil

black pastel pencil

light gray pastel pencil (Stabilo CarbOthello 1400/110 )

medium gray pastel pencil (Stabilo CarbOthello 1400/724)

white pastel pencil

**Other Supplies**
blending stump

drawing board

facial tissue

hole punch

kneaded eraser

mirror

pencil sharpener

ruler

scissors

slip sheet

white vinyl eraser

**Optional Supplies**
divider or sewing gauge

lightbox

pencil extender

spray fixative

transfer paper

# Pencils

There are many different types of pencils. Perhaps the most common *drawing pencil* has a core of graphite, carbon or charcoal encased in wood. Though pencils are not made from lead, the core is commonly referred to as *lead*.

## Graphite, Carbon and Charcoal

*Graphite* goes down smooth, but never gets truly black. If you want a really black color, use a *carbon* or *charcoal pencil*, but they can smear easily.

*Woodless graphite pencils* are made of a cylinder of graphite coated with lacquer. These pencils can make wide or thin strokes but can break in two if they are not handled with care. *Graphite* and *charcoal sticks* have no outer casing. Use the sides to make broad strokes, or use the ends for narrower strokes.

## Colored Pencils

Standard *colored pencils* can be waxy and hard to erase. Erasable and *pastel chalk colored pencils* offer similar results but with more versatility than standard colored pencils.

## Mechanical Pencils

*Mechanical pencils* are an alternative to traditional wood pencils. Though convenient, most mechanical pencils can only produce very thin strokes. *Lead holders* are mechanical pencils that grip a single piece of lead at a time. The graphite is about 1/16-inch (2mm) in diameter, wider than other mechanical pencil leads.

**Pencil Choices**
Some of the different types of pencils and drawing tools available are standard lead encased in wood, woodless, graphite and charcoal sticks, colored and mechanical pencils.

**Lead Holders**
Though characteristically similar to a wood pencil, the lead in a lead holder is prone to breaking if excessive pressure is applied to the tip.

**Extended Use**
Wood pencils that are too short to hold can be made useful with the help of a *pencil extender*.

harder                                                              softer

| 8H | 7H | 6H | 5H | 4H | 3H | 2H | H | F | HB | B | 2B | 3B | 4B | 5B | 6B | 7B | 8B |

**The Hard (and Soft) Reality**
The rating of the hardness of pencil lead is usually stamped on the pencil. H leads are hard compared to B leads, which are soft. F and HB leads are in between. Hard leads can't make rich darks like the soft leads; however, they hold a sharp point longer than soft leads.

## Keeping Your Pencil Sharp

To keep a sharp point on your pencil, you need to sharpen your pencil from time to time. Pencils can be sharpened with a *pencil sharpener* or by hand using a craft knife and *sandpaper pad*. Some artists choose to sharpen pencils by hand to better control the shape and amount of exposed lead.

### Lead It Be
A common misnomer is to call the core of pencils *lead*. Pencil cores are made of different materials such as graphite, carbon or charcoal, but not lead.

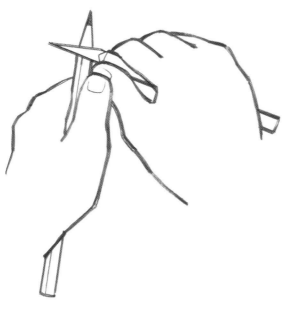

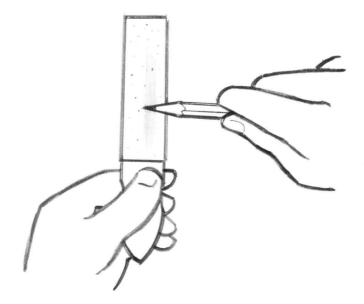

### 1 Trim the Wood
(Note: These instructions are for right-handed people. If you are left-handed, reverse the hand order.) With the pencil point directed outward, hold the pencil with your left hand, the craft knife in your right hand. Push your left thumb against your right thumb to create leverage so the blade cuts into the wood. Roll the pencil in your hand and repeat so the wood is trimmed and the lead core is exposed.

### 2 Sand the Lead
Drag the lead of the pencil back and forth over the sandpaper pad to sharpen the point.

**Pencil Sharpeners**
Many different types of pencil sharpeners offer a quick and easy way to sharpen pencils; the small types are especially good for travel.

**Sharpening Lead in a Lead Holder**
The lead in a lead holder can be sharpened using a *rotary lead pointer*. Simply put the lead holder with lead into the hole in the top and spin the top to sharpen the point.

# Paper

Paper for sketching and drawing varies in weight, size, surface texture, content and color.

## Weight

*Sketch paper* usually has a paper weight of 50 to 70 lbs. (105gsm to 150gsm), commonly thinner than *drawing paper*, which usually weighs 90 lbs. (190gsm) or more. The heavier weight paper is intended for finished drawings and will withstand heavy pencil pressure and erasing better than thinner papers.

## Size

Small pads are handy and portable for quick sketches. Bigger pads can also be used for quick sketches or finished drawings.

## Surface Texture

Surface texture, or *tooth*, may vary according to individual paper. The tooth of a paper identifies the roughness or smoothness of the paper and can be decided upon by the type of pencil used and desired results. Paper with a rough surface works well with soft pencils such as charcoal, while smooth paper lends itself to graphite pencils for more detailed results.

## Content

Sketching and drawing papers are made from wood pulp, cotton or a combination of the two. Cheaper paper may use wood pulp, which has an acid content, causing the paper to yellow over time. With this in mind, for finished drawings it's best to use acid-free paper.

## Color

You can use colored drawing paper for different effects. On neutral-colored paper, the drawing already has a middle value, so you can add both darks and lights instead of just darks. Colored drawing paper is available in individual sheets.

**Sketching and Drawing Pads**
Paper *pads* can be used as is, or you can remove individual sheets for use on a drawing board.

**Copier Paper**
If you have a fear of wasting a good piece of paper, try sketching on less expensive *copier paper*. Though this type of paper may not hold up over time, it may seem less intimidating for quick, loose observational sketches.

**Drawing Boards**
A *drawing board* placed behind a sheet of drawing paper provides a smooth, hard surface to control the amount of pressure applied with the pencil. Drawing boards come in different sizes and are made of Masonite or lightweight wood.

# Erasers

To lift pencil lines you may use an eraser. *Kneaded erasers* and *white vinyl erasers* work well with drawing; however, erasers are best used sparingly because they may distort the surface of the paper or smear the drawing.

Soft and putty-like, a kneaded eraser is very gentle to the paper's surface. To use, first press the eraser to the paper's surface and try lifting the marks. If this isn't enough, try rubbing the kneaded eraser against the paper surface going in just one direction. If this still isn't enough, switch to the white vinyl eraser.

Use a white vinyl eraser to remove hard-to-erase pencil lines. Vinyl erasers are easy to use and will not stain the paper.

## Erasing Shield

An *erasing shield* allows for more controlled erasing by isolating the area being erased. Hold the shield over the area you want to keep untouched while erasing the undesired areas through the holes or along the edges of the shield.

**Kneaded and White Vinyl Erasers**
These erasers are commonly used when drawing.

### Eraser "Tips"

Avoid using the eraser at the end of your pencil because it may smear pencil lines and stain the paper.

**Erasing Shield**
An erasing shield is a thin sheet of metal used for more controlled erasing.

9

# Additional Tools

In addition to the basic supplies, other tools will help make your drawing experience easier and more enjoyable.

## Proportional Devices

*Dividers* and *sewing gauges* can be used to measure proportions. A divider can be used with photos, and a sewing gauge can be used with both photos or drawings from life. See chapter 2 for more instruction.

## Mirror

A small handheld mirror is useful for observing your own facial features for details and expression.

## Lightbox

Artists use a *lightbox* to trace a structural sketch onto drawing paper. With the light from behind, tape the drawing paper over the structural sketch and trace the image onto the drawing paper. Or use a window instead of a lightbox.

## Facial Tissue and Blending Stumps

There may be times when using soft lead pencils that you want to blend the line work for a soft effect. Facial tissue works for large regions. *Blending stumps*, made of tightly rolled up soft paper, work for detailed blending.

These items can blend or soften the lines of a drawing.

## Transfer Paper

*Transfer paper* is another option for applying a structural sketch onto drawing paper. To make transfer paper, also called *graphite paper*, cover one side of a sheet of heavyweight tracing paper with soft graphite from a pencil or stick. Wipe a cotton ball slightly dampened with rubbing alcohol across the surface of the tracing paper to bind the graphite to the paper. When dry, place this sheet of paper graphite side down on top of a sheet of drawing paper and under the structural sketch. Using a hard lead pencil, go over the pencil lines to transfer the structural sketch onto the drawing paper.

## Fixative

Use *fixative* to prevent artwork from smearing. This is especially useful for carbon or charcoal drawings, which tend to be more powdery than graphite. Use proper ventilation when applying fixative.

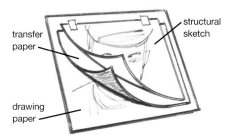

**Proportioning Devices**
Dividers and sewing gauges work well as proportioning devices.

**Using a Mirror**
Use a small mirror to observe your own facial features.

**Using a Lightbox**
Use a lightbox for tracing structural sketches onto drawing paper.

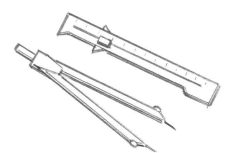

transfer paper

structural sketch

drawing paper

**Transferring an Image**
Transfer structural sketches onto drawing paper with transfer paper.

**Applying Fixative**
Spray fixative applied to drawings prevents smearing.

**Facial Tissue and Blending Stumps**
These items can blend the lines of a drawing.

# Setup

Here are some tips for setting up your work station, whether you choose to draw from photos or from life.

## Drawing From Photographs

Drawing from photographs allows you to study the subject in a two-dimensional form. In some ways, it may be easier to draw from photos because the subject is flat and unchanging. However, the life and personality of the subject are more likely to be captured by drawing from a live model.

## Drawing From Life

Drawing from a live model offers you the experience of capturing the personality of the model. However, not everyone will sit still for a prolonged period of time to have their portraits drawn. For this reason, you may want to keep a camera on hand to photograph the person and then complete the drawing from photos.

## Be Intentional About Lighting Subjects

An adjustable desk lamp or photography lamp can control the lighting of the subject to help you create interesting results.

Some artists prefer to draw portraits while standing, using an easel to prop the drawing board and paper. By standing, the artist can experience more freedom of movement.

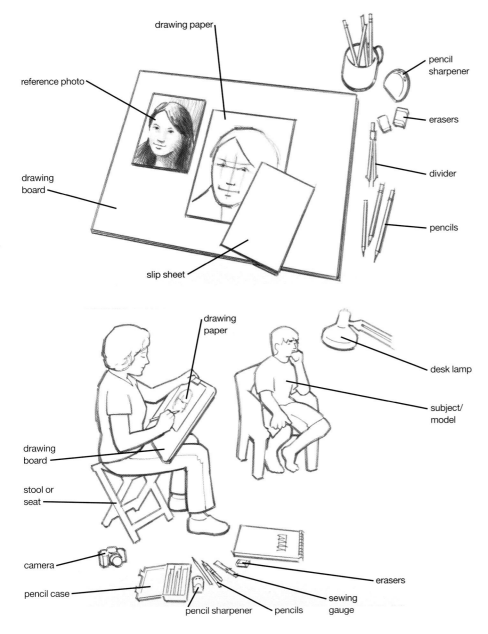

drawing paper

pencil sharpener

reference photo

erasers

drawing board

divider

pencils

slip sheet

**Drawing From Photographs**
Among the obvious supplies of pencils, pencil sharpener, erasers, drawing paper and drawing board, also included are the *reference photo*, divider and *slip sheet* to rest your hand without smearing pencil lines.

drawing paper

desk lamp

subject/ model

**Setup for Drawing From a Live Model**
Choose someone who is willing to sit as long as needed, or photograph the person in process to compete the drawing from photographs.

drawing board

stool or seat

camera

pencil case

pencil sharpener

pencils

sewing gauge

erasers

# 1 Techniques and **Principles**

As you sketch, you will be studying different aspects of your subject, capturing your observations through your sketches. A drawing is the culmination of the experience you gain as you study your subject by sketching.

Sketching and drawing can be thought of as two different activities. A *sketch* is a study or a work in progress. The process of sketching helps you to understand the structure and lights and darks of a subject. *Drawing* is the activity of producing a finished piece of art. As a beginner, if you are trying to do more drawings than sketches, then you may be putting too much pressure on yourself. Loosen up and enjoy learning how to express yourself through portraits.

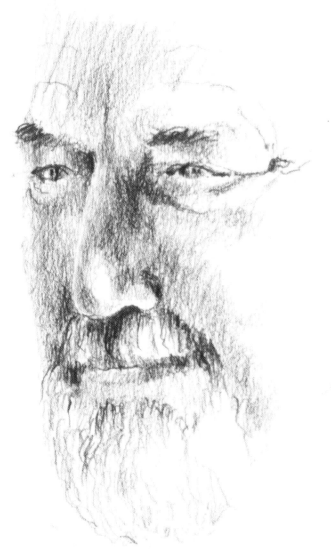

**T.R.**
Graphite pencil on drawing paper
8" × 5" (20cm × 13cm)

# Structure + Values = Drawing

Most of the drawings and demos included in this book are completed through a two-stage process. The first stage is the structural sketch. The second stage is adding the *values*, or lights and darks of the subject. This chapter will better describe these terms as well as other techniques and principles.

### Bright Idea

Work out the structural sketch on sketch paper, then trace by using a lightbox or transfer with graphite paper onto the drawing paper. By doing this, you will avoid much of the erasing on the drawing paper.

### 1 Start With Structure
The structural sketch is the foundation of the subject with basic lines.

### 2 Add the Values
After completing the structural sketch, add the values.

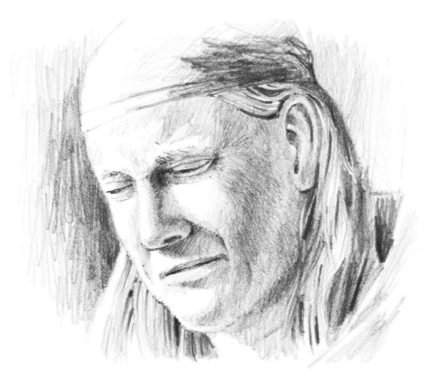

**The Finished Portrait**
Through this process you'll create the finished portrait by combining both the structure and values of the subject.

# Pencil Grips and Strokes

The way the pencil is held, the amount of pressure applied and the materials used all affect the line work of your art.

Different grips achieve different results, from long, loose or sketchy lines to short, tight lines. The grip can also influence the angle of the pencil to the paper, which affects the line width. When the pencil is held upright, only the point of the lead is in contact with the paper, producing narrow lines. When the pencil is tilted flat against the paper, the lead has more contact with the paper and produces wide lines.

As you sketch and draw, you will probably intuitively do what feels natural and hold your pencil in the manner needed to produce the pencil lines you want.

### For Wide, Loose Lines
Grip the pencil with your thumb and fingers so the pencil rests under your palm. Position the pencil lead flat against the paper surface. Make loose, fluid line strokes by moving your entire arm instead of just your hand and wrist.

### For Wide, Short Lines
Hold the pencil closer to the tip, allowing for more pressure on the lead. Movement comes from the forearm, while the hand and wrist are kept rigid against the paper surface.

### For Narrow, Short Lines
This is like a handwriting grip, with the pencil angled in relation to the paper to make narrow lines. Movement comes from your hand rather than your arm and wrist, making for more controlled pencil strokes.

### For Long Lines
This also uses a handwriting grip but with the pencil held farther from the tip. Movement comes from your hand while it rests on the paper. The angle of the pencil to the paper and the sharpness of the lead influence the width of the pencil strokes.

| | wide, loose lines | wide, short lines | narrow, short lines | long lines |
|---|---|---|---|---|
| graphite pencil | | | | |
| charcoal pencil (similar to carbon and pastel colored pencils) | | | | |
| mechanical pencil | | | | |

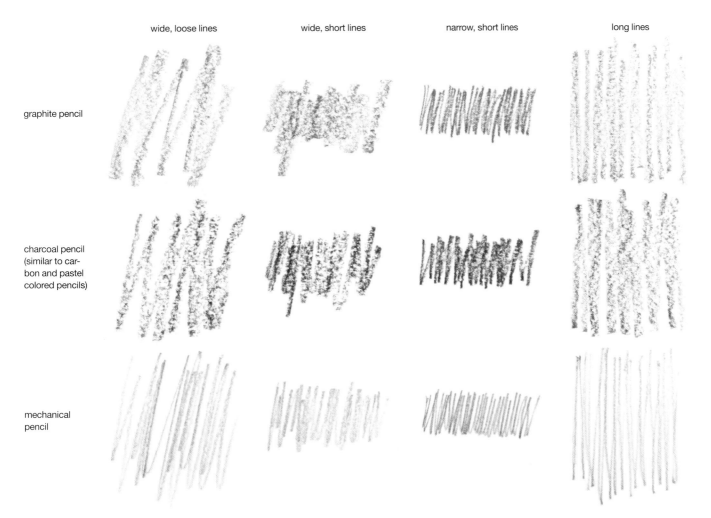

## Using Different Strokes

Notice the different results? Pressure and grip will affect the line results of your drawing. You may find that you like certain grips and pencil lines better than others. Generally, the more pressure you apply, the darker your lines will be.

### *Scribbling*

Just as it sounds, scribbling is simply pencil lines going in random directions. This can make a sketchy look.

### *Crosshatching*

For this technique, make sets of pencil lines overlapping in different directions.

### *Gradation*

Make a set of pencil lines varying in darkness by adjusting the amount of pressure.

# Different Approaches

Some approaches to drawing a subject include structural sketch, value sketch, black-and-white sketch, contour sketch and blind contour sketch.

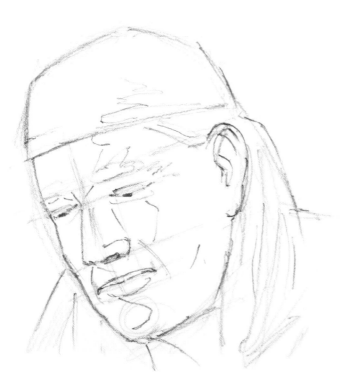

**Structural Sketch**

In a *structural sketch*, basic lines define the form of the subject. These lines show the placement of features and proportions. A structural sketch by itself has no values.

**Value Sketch**

A *value sketch* shows the form of the subject through a range of lights and darks.

## A Thread of Lead

Try to do a contour drawing without lifting your pencil. When finished, you could pull it apart with one good yank!

### Black-and-White Sketch

In a *black-and-white sketch*, also called *chiaroscuro*, the subject is shown through solid white and black regions without middle values.

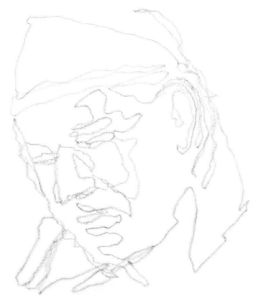

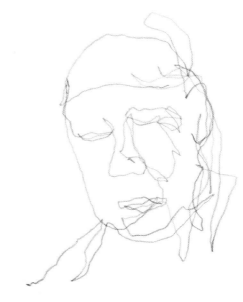

### Contour Sketch

In *contour sketch*, also called a *continuous line sketch*, a continuous line defines the form of the subject. Contour sketching is a fun way to develop your observational skills. Just put your pencil to the paper and let it wander without lifting it up until you are done. Capture the highlights and shadows as you also draw the basic structure of your subject.

### Blind Contour Sketch

A *blind contour sketch* is a contour sketch done without looking at the sketch as it is in progress. To do this, use a piece of cardboard to block your view of your paper while you are sketching. My students always get a laugh out of this exercise.

# Combining Approaches

As stated earlier in the chapter, throughout this book we'll use structural sketches as the beginning stage of more finished drawings that have had values added to them for the final result. Having a structural foundation underneath your drawing can make it easier to study other aspects of your portrait and combine different approaches to sketching and drawing.

## Trace or Transfer the Structural Sketch

The structural sketch can be directly on the drawing paper for the finished drawing or on a separate sheet of paper and then traced or transferred onto the drawing paper. Tracing the structural sketch onto the drawing paper reduces the need to erase unwanted lines on the drawing paper. Erasing on drawing paper can damage the delicate surface of the paper.

Tracing uses a lightbox or window; transferring uses transfer paper. Both procedures are detailed in the introduction of this book.

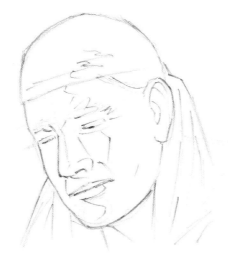

**Making a Structural Sketch**
The structural sketch is the foundation for the finished drawing. Start by sketching the basic overall proportions and placement of features. Next add the features, then add more detail to the features. You can include lines indicating the regions of shadows.

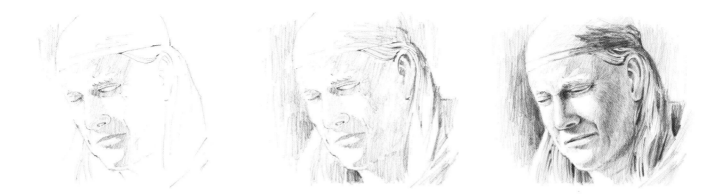

## Making a Drawing With Values

Add values over the structural sketch for a finished drawing. Build up the lighter values with a series of lines. Add darks throughout the process or at the end.

## Making a Black-and-White Drawing (Chiaroscuro)

Draw solid black areas using a carbon or charcoal pencil over the structural sketch. This study of your portrait is defining the pure white of the lights and highlights and the black of shadows. There are no in-between values in this study.

## Making a Contour Drawing

To focus on the contours of the face, start with a structural drawing as the foundation beneath your drawing paper on a lightbox. Studying the subject, draw the subtle lines, curves, highlights and shadows of the face. This isn't done with sketchy pencil lines but with flowing pencil lines, so you may lift your pencil from the paper only a few times during the whole process, if at all.

# Understanding Values

Values are lights and darks that give form and depth to a subject. Observing the wide range of values that make up your subject will give you a better understanding of how to complete your portrait.

## Using Contrast: More or Less?

The way you use contrast affects the appearance of the subject. More contrast makes for a broader range of values: the features are sharper and more distinct, and the portrait is more dramatic. With less contrast, the range of values is narrower. The overall feeling is softer and with less depth.

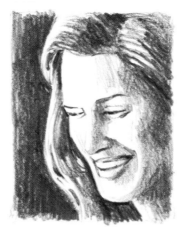 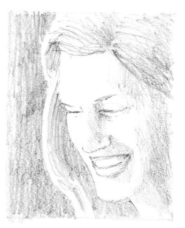

## Values Appear Relative

Values can appear different depending on their surroundings. A silhouette of a person in a gray value may seem dark when placed on a white background. That same silhouette seems lighter when placed against a darker background.

## Using a Value Scale

A value scale is used by holding it against the subject and comparing the values with those of the drawing.

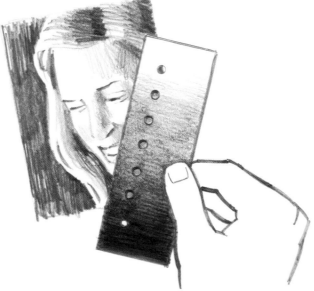

# Making a Value Scale

**MINI-DEMONSTRATION**

A *value scale* is a strip of paper or cardboard that has a range of values from white to black. The purpose of the value scale is to identify the values of the subject and compare those with the drawing. Cardboard value scales are available at art stores or you can make one with pencils and drawing paper.

## Materials

4" × 8" (10cm × 20cm) medium-tooth drawing paper

2B graphite pencil

8B graphite pencil

hole punch

ruler

scissors

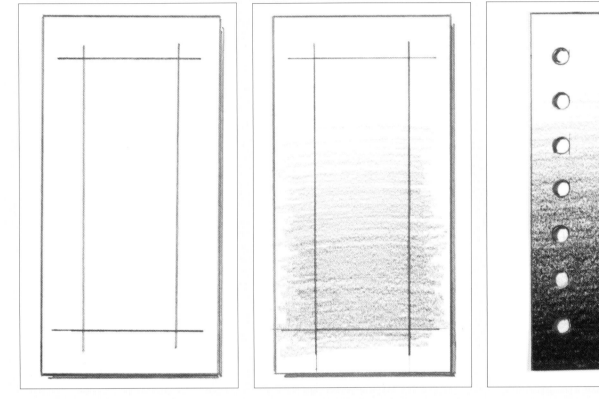

**1 Draw a Rectangle**
Use a pencil to draw a 2" × 6" (5cm × 15cm) rectangle on the drawing paper.

**2 Shade the Lower Half**
With a 2B pencil, darken the paper with graphite, gradating the graphite light to dark, keeping the top portion white.

**3 Finish Shading and Punch Holes**
Continue to darken the drawing paper with an 8B pencil so the bottom is fully dark. Trim the 2" × 6" (5cm × 15cm) rectangle with scissors and punch out a line of holes with a hole punch.

# Light Effects

The play of light and shadow can drastically affect the appearance of a subject. Understanding the light in relation to the subject will influence the depth and mood of your drawing.

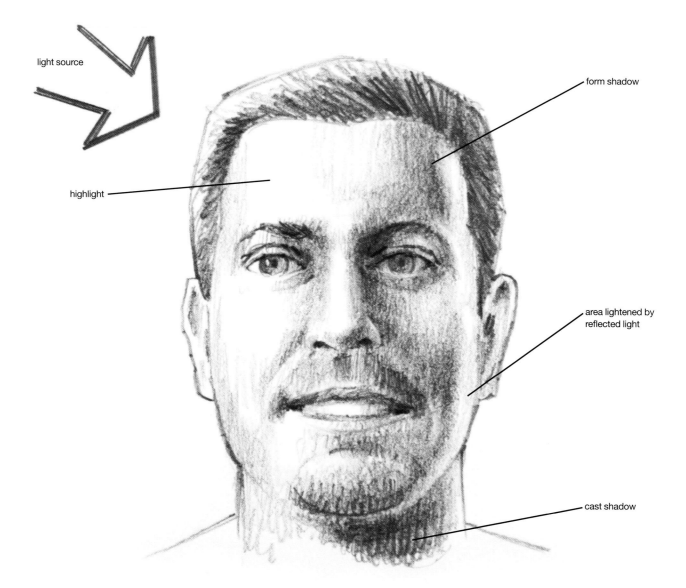

light source

form shadow

highlight

area lightened by reflected light

cast shadow

## Typical Lighting of a Subject

The *light source* is the primary origin of the light. Most light sources (whether natural or artificial) are above a subject. Areas directly exposed to the light source are the lightest regions. A *highlight* is a bright spot on the subject, such as on the forehead. Those areas most recessed and turned away from the light source are darkest.

Some areas may be exposed to *reflected light*, or a secondary light source. Typically, reflected light is not as bright as the primary light source. It may throw subtle light onto an area that would have otherwise been dark.

*Form shadows* display the form of the subject, such as the subtle value changes on the dark side of the forehead.

*Cast shadows* are caused by one form casting a shadow on another form, such as the chin casting a shadow on the neck.

## Observing Light Effects With a Plaster Cast or Mannequin

Facial light effects can be observed with a plaster cast face or a Styrofoam mannequin head that you can find at art or hobby stores.

# Lighting the Subject

Changing the light source of the subject affects the shadows and definition of the forms. Adapt the lighting and the background to the subject to create a more natural feel for the portrait.

**Light From Front**
Features look flat; the face lacks dimension.

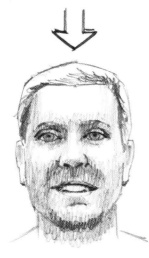

**Light From Above**
Dramatic but symmetrical; face in shadow.

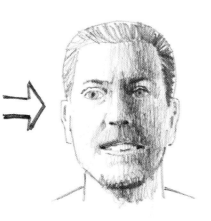

**Light From Left Side**
Interesting but harsh.

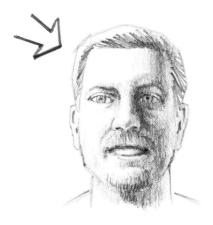

**Light From Top Left**
Natural and pleasing; shows the forms well.

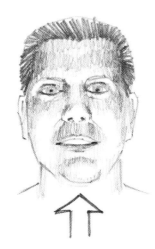

**Light From Below**
Unusual and unnatural appearance.

**Light From Left Back and Top**
Dramatic and unusual.

# 2 Proportions

Facial proportions are generally the same from person to person. However, there are subtle differences in the size and placement of features that make each of us unique.

*Proportioning* involves examining and comparing the size and placement of features. As you work on your proportioning, remember to start with a light touch so you can make adjustments without having to erase any more than you have to.

A pencil or sewing gauge works well for proportioning. A divider can also be used when working from a photograph.

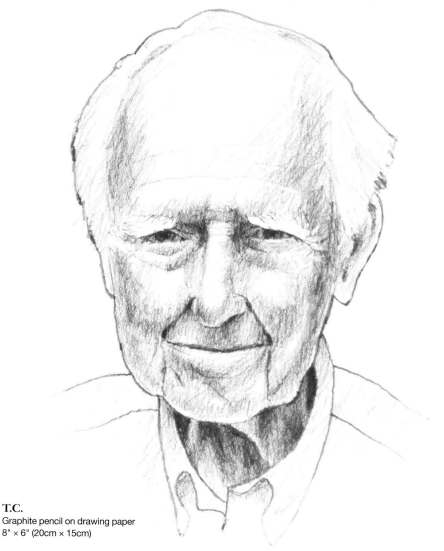

**T.C.**
Graphite pencil on drawing paper
8" × 6" (20cm × 15cm)

## Great Expectations!

Don't be surprised if, at the beginning, your sketch looks nothing like the person you are trying to draw. Persevere! It is in the final stages that you will add the details to make your person unique.

# Measuring

Sketching is a work in progress. You'll make adjustments to the sketch when comparing and measuring proportions. Some features can be used as a unit of measurement to compare size and to place other features. A sewing gauge is a good tool for measuring.

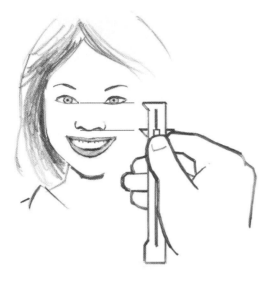

**1 Find a Comparison Measurement**
In this example, the distance from the eyes to the base of the nose will be the unit of measurement.

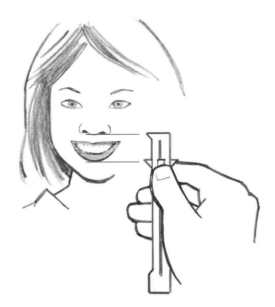

**2 Use the Measurement**
This unit of measurement happens to be equal to the distance from the base of the nose to the bottom of the lower lip.

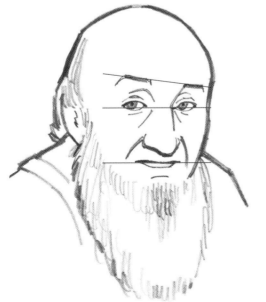

**Lining up Features**
Look to see which features line up or are angled when compared to one another. The horizontal lines representing the mouth and eyes are parallel, while the eyebrows are angled in comparison.

## Proportions Made Easy

Hold up a piece of drawing paper alongside the subject to visually line up the features horizontally, showing the placement of the features. This is especially useful when drawing profiles.

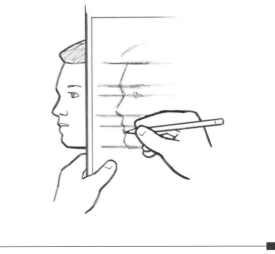

# Male Proportions, Front View

Accurately sketched placement of features and proportions are necessary for a likeness of the subject. A common misproportion is to place the eyes up too high instead of toward the center of the head. Hair that covers the forehead may give the false sense that the middle of the head is much higher than it actually is.

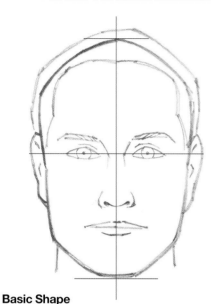

**Basic Shape**

The shape of the head is similar to the shape of an egg. The eyes are approximately halfway from the top of the head to the bottom of the chin.

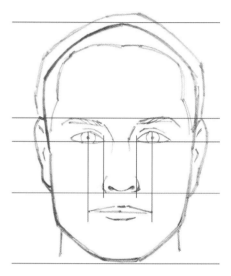

**Basic Measurements**

Using the width of the eye as a unit of measurement, the average head is proportionally five wide by seven high, with one eye width between the eyes.

**Lining Up**

Some features line up horizontally with other features. Notice that the base of the nose lines up with the bottom of the ears, and the brows line up with the top of the ears.

As for vertical lines, the width of the base of the nose is similar to the distance from eye to eye, and the width of the mouth is the same as the distance between the pupils of the eyes.

## Proportions Run Amok

*Caricatures* are created by distorting proportions and exaggerating prominent features of the subject.

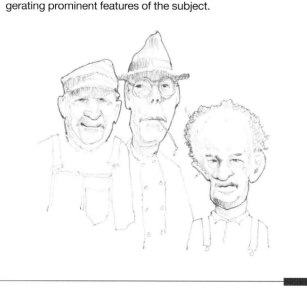

# Male, Front View Structural Sketch

**MINI-DEMONSTRATION**

To draw faces correctly, it's important to understand their basic structures and proportions. Notice in this mini-demo that many of the facial features line up with each other.

## Materials

8" × 10" (20cm × 25cm) sketch paper

2B pencil

kneaded eraser

**1 Draw the Basic Head Shape**
Develop the basic shape and add horizontal and vertical center lines.

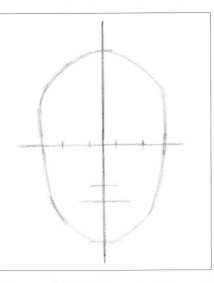

**2 Add Feature Lines**
Add the nose and mouth lines and width lines for the eyes.

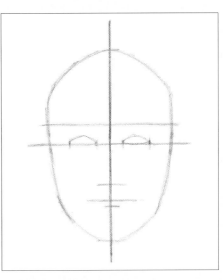

**3 Draw Brow Lines and Eyes**
Add horizontal lines for the brows and lower lip. Sketch the eyes.

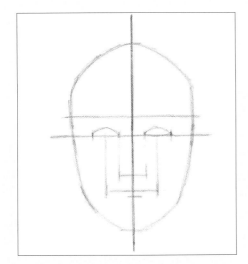

**4 Determine Nose and Mouth Widths**
Add vertical lines down from the inside corners of the eyes for the width of the nose and lines down from the center of the eyes for the width of the mouth.

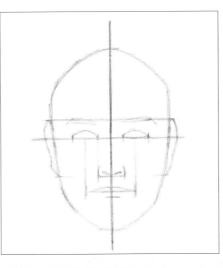

**5 Sketch the Facial Features**
Sketch the shapes of the brows, ears, nose and mouth.

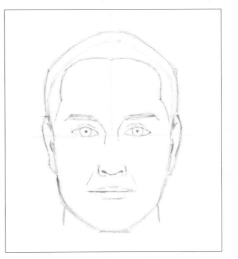

**6 Finish the Features**
Sketch the hair and neck, facial lines, irises and pupils. Erase unwanted lines.

# Male Proportions, Side View

From top to bottom, the placement of facial features is proportionally the same on both the front and side views. Profile shape is important as well as the placement of the eye and ear.

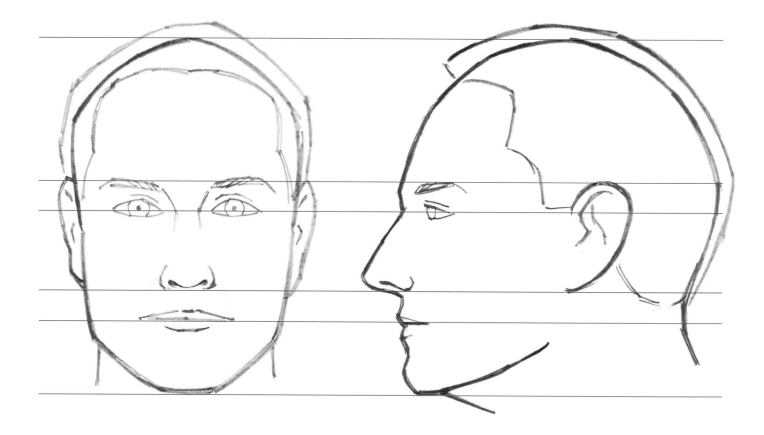

**Lining Up**
Adding horizontal lines shows that the placement of the features lines up from front to side.

# Male, Side View Structural Sketch

**MINI-DEMONSTRATION**

Placing the elements for a side view is similar to placing them on a front view. Look for proportions and places where the facial features line up.

## Materials
8" × 10" (20cm × 25cm) sketch paper

2B pencil

kneaded eraser

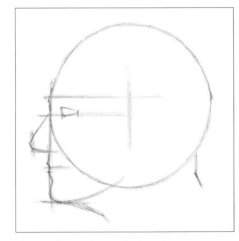

**1 Sketch the Basic Head Shape**
Sketch a circle, then add a vertical line on the left of the circle as the beginning profile, a horizontal line below the circle and a horizontal line for the eyes, centered top to bottom between the chin line and the top of the circle.

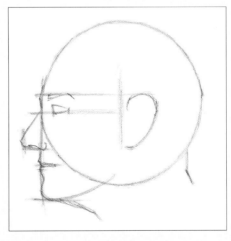

**2 Add Feature Placement Lines**
Add horizontal lines indicating placement of the nose and mouth, and small vertical lines for the placement of the eye.

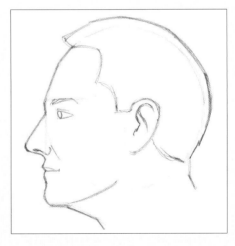

**3 Add Brow, Lip, Ear and Nose Lines**
Add horizontal lines for the brow and lower lip. Add a vertical line at the center of the circle for placement of the ear and another vertical line for the end of the nose.

**4 Draw the Profile, Eye, Nose, Chin and Neck**
Form the profile, and add the eye and nose. Then add the chin and neck.

**5 Form the Other Features**
Add the brow, nostril and lips. Add the ear to the right of the vertical center line.

**6 Draw the Hair and Complete the Features**
Add hair and facial lines, and erase unwanted lines.

# Male Proportions, Three-Quarter View

Front, three-quarter and side views are all the same regarding the placement of facial features from top to bottom. The vertical center line of the front view is moved left (or right) and is useful for the placement of the other features.

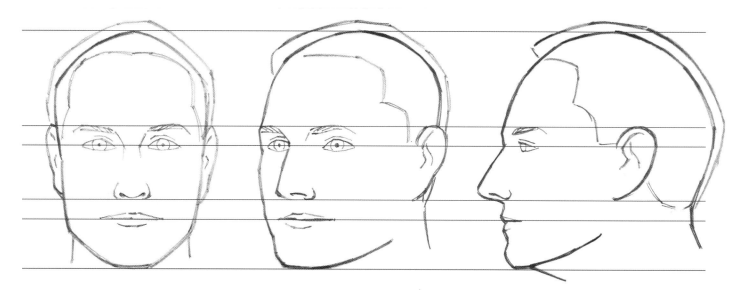

## Facial Characteristics

Though the facial features of a subject change shape and width, their placement is the same from top to bottom for front, three-quarter or side views.

## Egghead Observation

The adult head is shaped similar to an egg. Draw lines on an egg to represent the placement of facial features, and observe how these lines change according to its positioning.

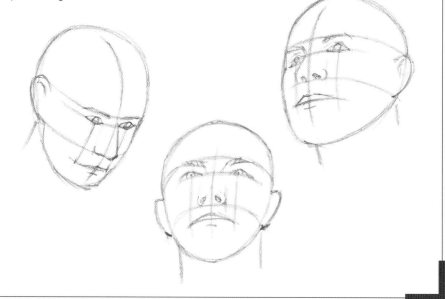

# Male, Three-Quarter View Structural Sketch

**MINI-DEMONSTRATION**

A three-quarter view of the face shows most of the face and part of the side of the head. Keep in mind that the proportions and the placement of the facial features are similar to the front view.

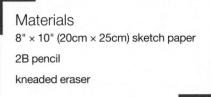

## Materials
8" × 10" (20cm × 25cm) sketch paper

2B pencil

kneaded eraser

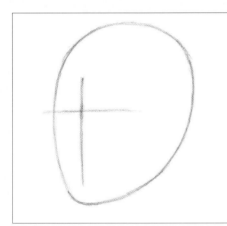

**1 Sketch the Basic Head Shape**
Sketch the basic egg shape with a horizontal line centered top to bottom. Add a slightly curved vertical line on the left side as a center line for the face.

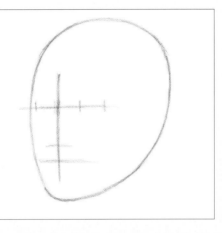

**2 Add Feature Placement Lines**
Add horizontal lines for the nose and mouth lines. Sketch the width of the eyes with small vertical lines.

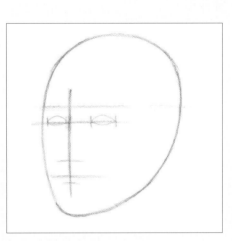

**3 Place the Brows and Lips and Sketch the Eyes**
Add horizontal lines for the brows and lower lip. Sketch the eyes.

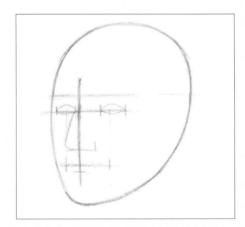

**4 Place the Nose and Mouth**
Sketch vertical lines down from the inside corners of the eyes for the width of the nose, and sketch the side of the nose. Add lines down from the center of the eyes for the width of the mouth.

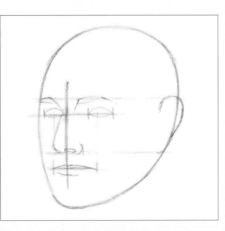

**5 Draw the Features**
Sketch the shape of the brows and ear. Form the lower nose and mouth.

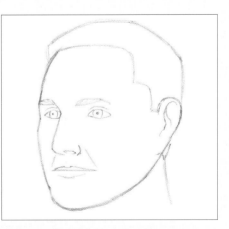

**6 Finish Drawing the Features**
Add the hair and neck, facial lines, irises and pupils. Erase unwanted lines.

# Female Proportions

While proportions are basically the same, the differences between male and female faces are noticeable with the individual features, especially when put together as a whole. These characteristics are generalizations and may not fit every person.

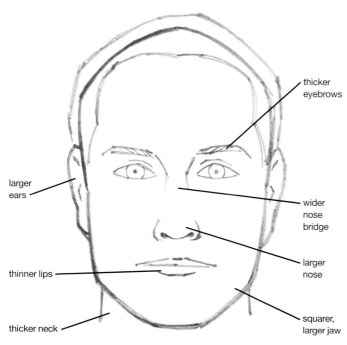

thicker eyebrows

larger ears

wider nose bridge

larger nose

thinner lips

squarer, larger jaw

thicker neck

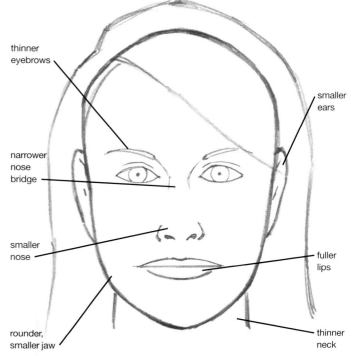

thinner eyebrows

smaller ears

narrower nose bridge

smaller nose

fuller lips

rounder, smaller jaw

thinner neck

## Comparing Male and Female Features

While the placement of the features may be the same overall, there are subtle differences that express gender. Most of the male features are bigger and bulkier, whereas female features are smaller and more delicate, with the lips as the exception. A female's eyes may appear larger than the eyes of a male, but they look this way only because the surrounding features are smaller. In reality, the eyes are usually the same size.

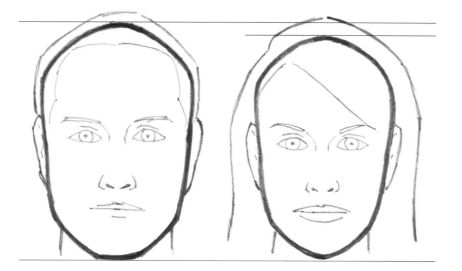

## Comparing Size

When comparing size, men have bigger heads than women. (No pun intended!)

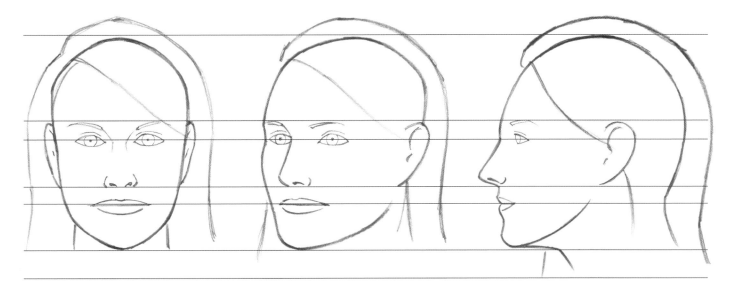

**Feature Lineup in Front, Three-Quarter and Profile Views**

## Let's Make Up
Cosmetics, such as dark mascara and lipstick, along with earrings can add to the feminine appearance of a female face.

# Elderly Proportions

Skin becomes less hydrated and thinner as we age, causing wrinkles, sags and thinner lips. Continued bone growth is noticeable in the nose, jaw and forehead. Ears can become a bit more outstanding. Hair grays and thins, except for the eyebrows, which may actually become bushy for males, and we won't even discuss their ear hair growth!

**Elderly Male**
To me, old men can be the most fun to draw. The effects of age add character to the subject.

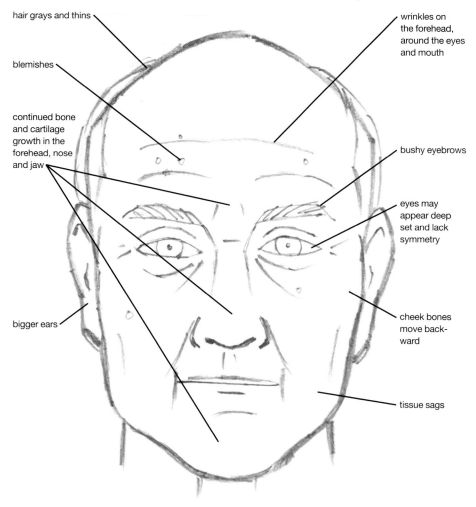

hair grays and thins

blemishes

continued bone and cartilage growth in the forehead, nose and jaw

bigger ears

wrinkles on the forehead, around the eyes and mouth

bushy eyebrows

eyes may appear deep set and lack symmetry

cheek bones move backward

tissue sags

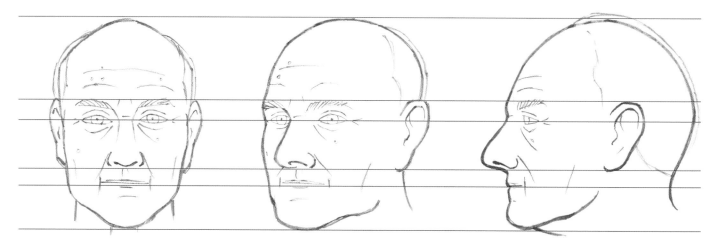

**Feature Lineup in Front, Three-Quarter and Profile Views**

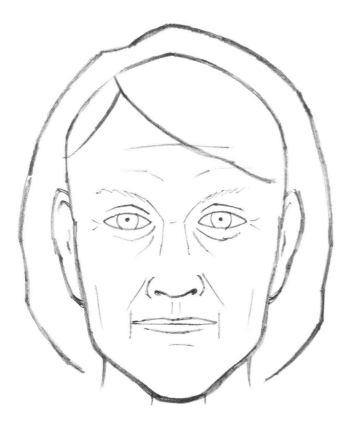

**Elderly Female**
Hairstyle can suggest a person's age or era. If you are drawing an older woman that you know, you might "enhance" your drawing by making the portrait look somewhat younger than she actually is.

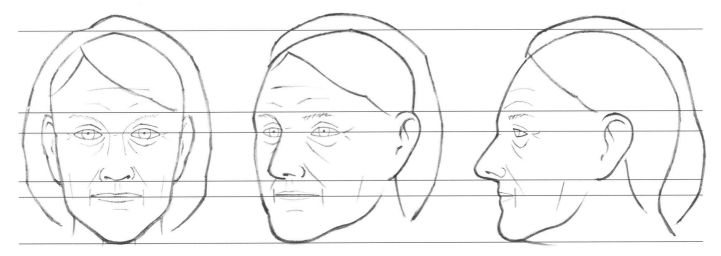

**Feature Lineup in Front, Three-Quarter and Profile Views**

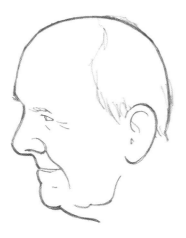

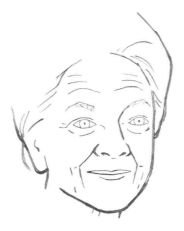

**The Beauty of Age**
Age can have its own appeal and show character.

# Child Proportions

Facial proportions and features of boys and girls are very similar. It isn't until young adulthood that the face displays features more specific to being male or female.

Babies' heads are short and wide. As the head develops, it becomes longer, lengthening the features such as the nose and ears.

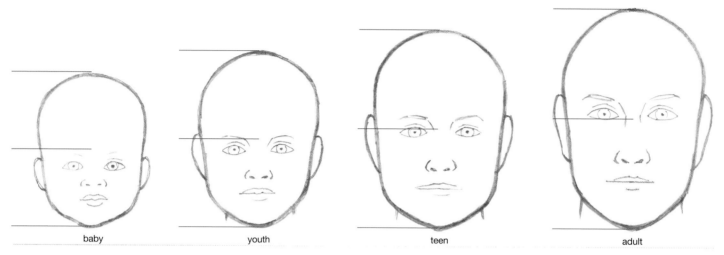

baby

youth

teen

adult

## Growing Changes
As the head develops from baby to adult, the overall shape becomes longer and proportionally narrower. The eyes of the baby are well below the center line, whereas the eyes of an adult are at or above the center line. The nose and ears also grow and lengthen.

baby

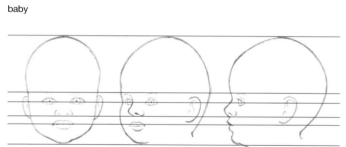

teen

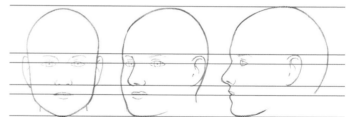

youth

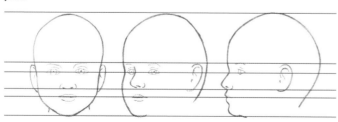

## Feature Lineup in Front, Three-Quarter and Profile Views
Just as adult features line up in front, three-quarter and profile views, so do the features of babies, children and teens.

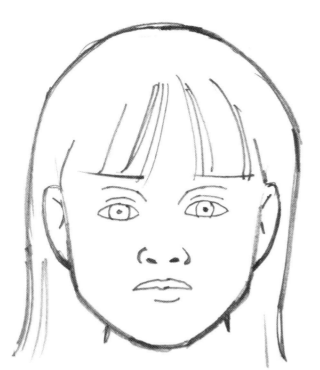
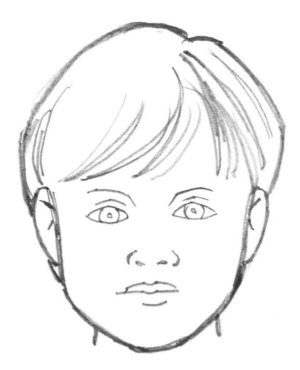

## Girl and Boy Hairstyles

Hairstyle can suggest whether a child is a boy or a girl. The faces shown here are exactly the same; only the hair is drawn differently.

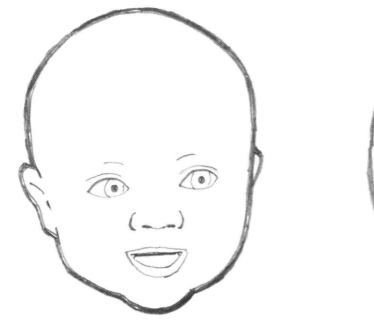
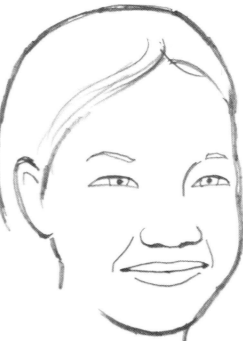

## Age-Appropriate Proportions

Both of these portrait sketches are of young children, but the proportions define one as a baby and the other as a young girl.

# Facial Expressions

Expressions are fun to draw. Facial expressions involve more than just the mouth and eyebrows. They involve the muscles that change the contour and shape of the face. A smile pulls the cheeks up along with the corners of the mouth and affects the shape of the eyes and brows. A frown pulls down the cheeks, turning down the corners of the mouth and affecting the other features.

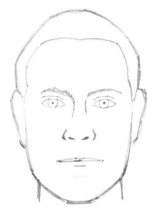

Relaxed

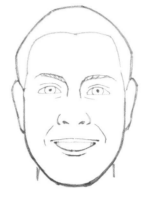

Happy

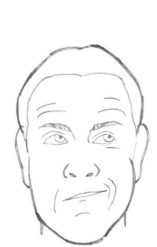

Sad

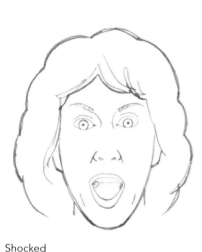

Shocked

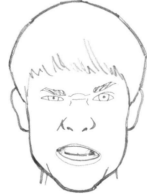

Angry

Doubtful

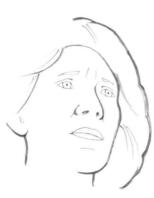

Worried

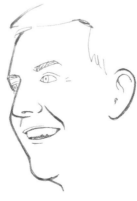

Smiling

## Making Faces
Try examining your own facial expressions with a mirror when drawing. You will probably find yourself making the same facial expression that you are drawing.

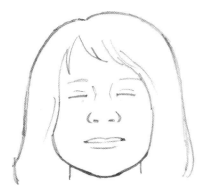

Peaceful

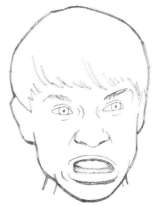

Hysterical

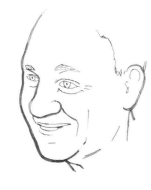

Pleased

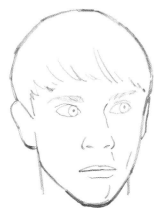

Suspicious

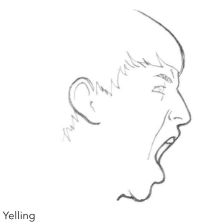

Yelling

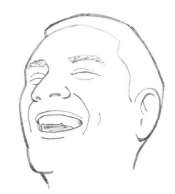

Laughing

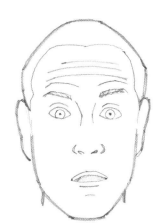

Confused

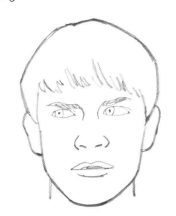

Perturbed

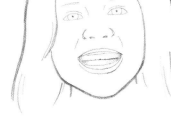

Surprised

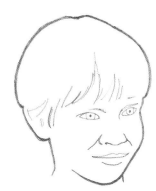

Thoughtful

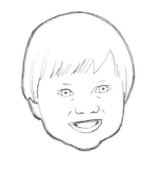

Attentive

Jovial

# 3 Features

Each portrait includes unique features that combine to express the individuality of a person. A portrait is easier to draw when you break it down into separate facial features. Instead of looking at the face as a whole, first map out the placement of the facial features and then concentrate on them individually.

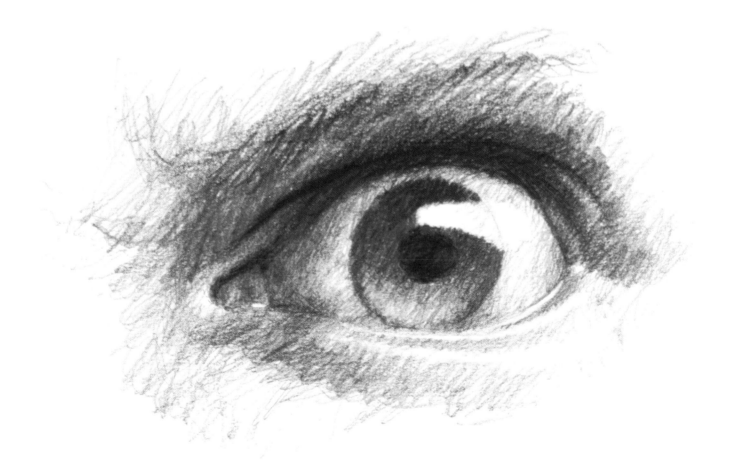

**Me, Myself and Eye**
Graphite pencil on drawing paper
6" × 9" (15cm × 23cm)

# Eyes

It has been said that the eyes are the window to the soul. The eyes express personality and emotion and are perhaps the most important feature of a portrait.

The cornea is the clear part of the eye that covers the iris and pupil and bulges out from the ball of the eye. Depending on how the eye is viewed, the bulge of the cornea and its effects may be noticeable when it presses out the upper eyelid.

The placement of the pupils and irises in a portrait drawing suggests where the subject is looking. Pupils and irises spaced apart can give the impression that the person is pensive or looking into the distance.

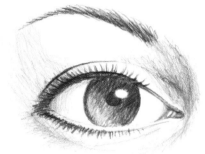

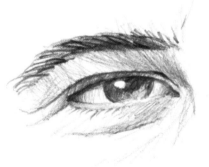

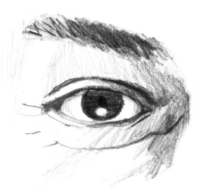

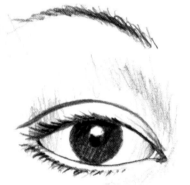

## Eye Individuality
The individuality of eyes involves not only the pupil and iris, but also the eyelids, brow, crease and wrinkles. How deeply the eye is set affects the shadows and may darken the white of the eye.

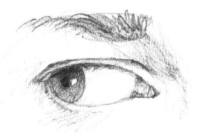

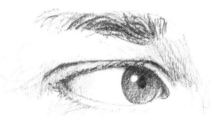

## Changing Forms
The cornea's convex shape causes the form of the eyelids to change according to the direction of the eye. With the iris/pupil to the outside, the top and bottom eyelids are spread farthest apart on the outer side, exposing the fleshy inside corner of the eye. With the iris/pupil to the inside, the eyelids are spread farthest apart on the inside, with only a small amount of the inside corner of the eye exposed.

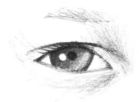
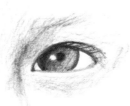
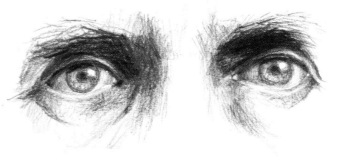

## Youthful Eyes

Children's eyes are clear and bright with big irises and soft shading.

## Expression of Age

An elderly person's eyes may be set deep in their sockets. Other characteristics may include a darkening of the white areas and a cloudiness to the irises and pupils. The eyes may also have a watery appearance.

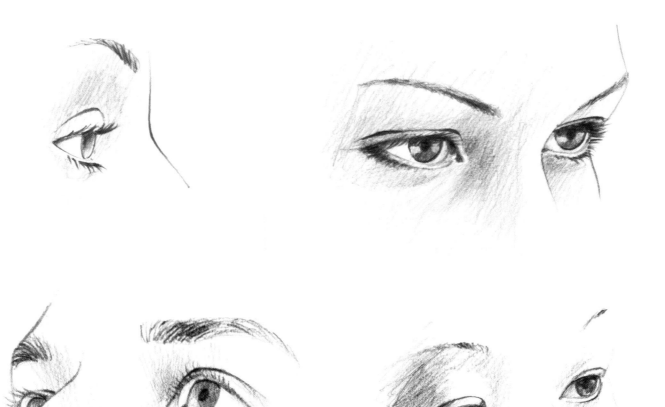

## Different Views

When viewed from the side, the eye shape is triangular, formed by the top and bottom eyelids and the cornea. Placement of the eye from the nose bridge is important for the correct appearance. The cornea appears as a narrow elliptical shape. At three-quarter view, the irises and corneas are elliptical, and the nose bridge partially covers the far eye.

# The Eye
## MINI-DEMONSTRATION

Try drawing big and observe the many features included with the eye. This is a young man's eye, with full eyebrow and few wrinkles.

### Materials
8" × 10" (20cm × 25cm) sketch paper

2B pencil

kneaded eraser

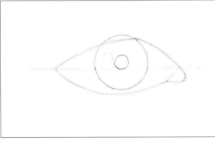

### 1 Sketch the Basic Shape, Iris, Pupil and Highlight
Beginning with a horizontal guideline, sketch the top and bottom eyelid lines to make the shape of an opened eye. Pay attention to the width and height for accurate proportions. Notice how the lids curve according to the shape of the eyeball.

Sketch a full circle for the shape of the iris. The part of the circle above the top lid can be erased later. Sketch the pupil and highlight.

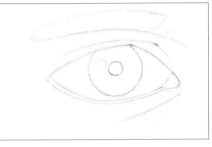

### 2 Sketch the Lower Brow, Eyelid Crease, Lines, Brow and Detail Lines
Sketch the shape of the lower (underneath) part of the eyebrow. This is formed as a recession by the eye socket. Add the top eyelid crease and lines below the eye.

Sketch the shape of the brow and add detail lines around the lower eyelid. Erase unwanted lines.

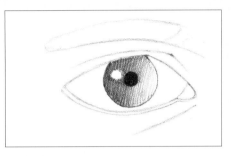

### 3 Start Adding Values
Start adding the values beginning with the pupil and iris, considering the direction of light and its effects. Keep the highlight white to show reflected light on the cornea. The clear cornea may cause the side of the iris opposite the light source to appear lighter.

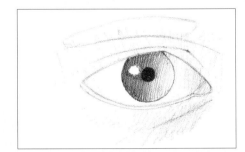

### 4 Add Values on and Around the Eye
Add values to the white areas of the eye as well as to the areas around the eye, such as the upper and lower lids.

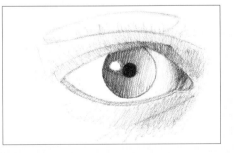

### 5 Add More Values
Add more values on and around the eye, giving more form to the ball shape of the eye.

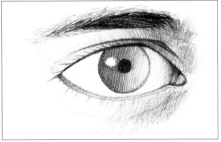

### 6 Add Final Darks and Details
Darken as needed, including the crease on the upper lid, and add details including the brow hairs and eyelashes.

# Noses

Noses are narrow at the top and wide at the bottom, with their proportions and forms unique to the individual.

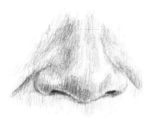 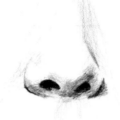 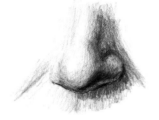 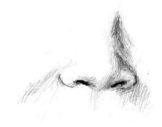

### Front Views

Drawing noses from the front can be challenging because most of the form is shown by subtle variations of lights and darks rather than outlines. A profile may seem easier because the shape can be drawn with a line.

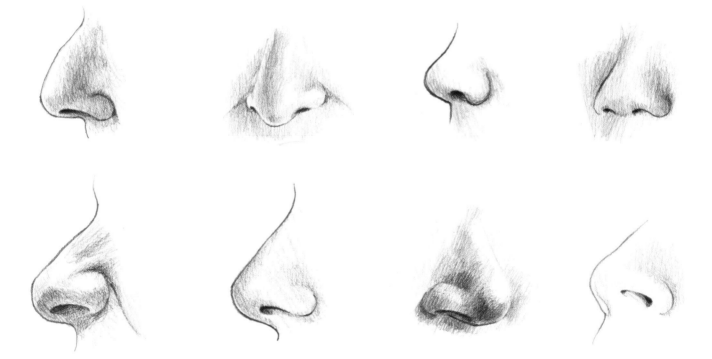

### The Character of the Nose

Noses come in many shapes and sizes.

## Get Nosey

It may be visibly noticeable where the bony part of the nose bridge ends and where the cartilage begins. Try observing your own nose with a mirror and feeling its structure to recognize this transition.

# The Nose

**MINI-DEMONSTRATION**

This is an older man's nose and is characteristically long and large. As with all features, be conscious of where the light source is coming from. In this drawing, the light is coming from the upper right, causing highlights on the right side of the nose and dark regions on the left and bottom.

## Materials
8" × 10" (20cm × 25cm) sketch paper

2B pencil

kneaded eraser

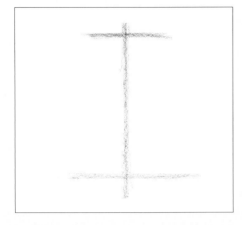

### 1 Sketch a Center Line, Eye Line and Bottom Line
Sketch a vertical line representing the center of the nose. Sketch a horizontal line where the eyes would line up at the nose bridge. Sketch a line for the bottom of the nose.

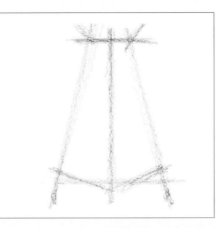

### 2 Sketch Sides, Brows and Nostril Lines
Sketch the sides as well as part of the brows that intersect at the eye line. Sketch two lines at the bottom for the placement of the nostrils.

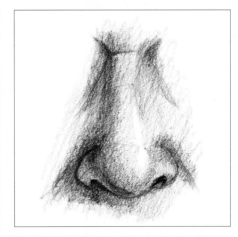

### 3 Develop the Structural Lines and Shadow Lines
Develop the structural lines and rounding lines, and add detail to the nostrils. Add a circle toward the bottom to develop the shape of the lower part of the nose and the nostrils. Add lines for wrinkles and placement of shadows. Erase unwanted lines in the process.

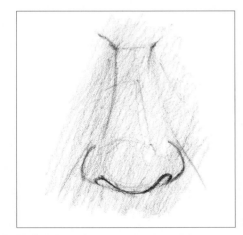

### 4 Start Shading
Start shading with a light overall value. Highlighted areas can be shaded around or erased later.

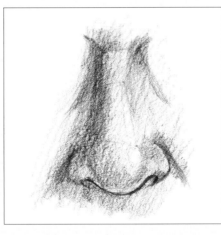

### 5 Add Darker Values
Add darker values, mostly on the left side since the light is from the right. In this example, the lower part of the nose is ball-shaped and can be shaded like a ball.

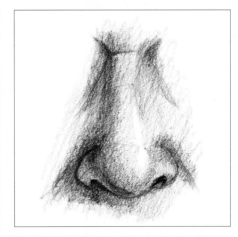

### 6 Finish With Darks and Highlights
Add darks in the shadowed areas, including the nostrils. Create highlights by pressing the kneaded eraser onto those areas to remove graphite.

# Mouths

What would our faces be without mouths? We would talk a lot less. It would be difficult to eat. We wouldn't have to brush our teeth, saving us about five minutes per day. Spread over the average lifetime, this adds up to over fourteen weeks!

Mouths by themselves may not seem very important, but they can speak with a lot of personality. They can express a person's age, gender, origin and, of course, emotion.

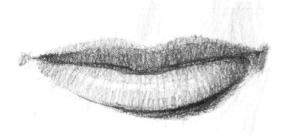

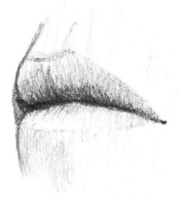

### Age of the Mouth
Large full lips are recognized as youthful. Thin lips look aged.

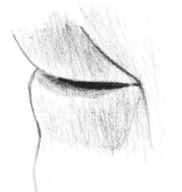

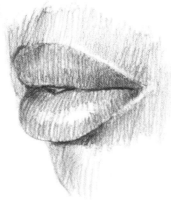

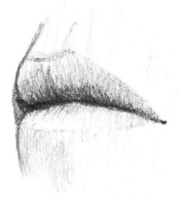

### The Character of the Mouth
Lips can be different shapes. Since the light source is usually from above, the top lip will be shadowed and the lower lip will receive more light.

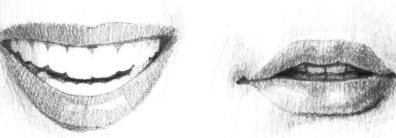

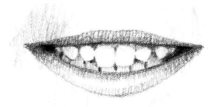

### Teeth
Adult teeth may appear as a group of teeth defined by their bottom or top edges rather than their individual outlines. As the teeth recede into the mouth, they appear more shadowed.

Children's teeth are smaller and less developed than adult teeth and are seen as individual teeth.

# The Mouth

## MINI-DEMONSTRATION

This woman's mouth indicates youth and beauty with full lips and white teeth. The soft smile indicates contentment.

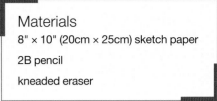

Materials
8" × 10" (20cm × 25cm) sketch paper
2B pencil
kneaded eraser

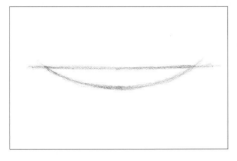

### 1 Sketch the Basic Shape
Sketch the basic shape of an opened mouth with a horizontal top line and a curved bottom line that connect at the sides.

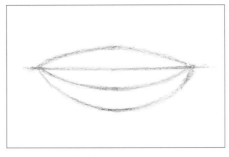

### 2 Sketch the Lip Shapes
Sketch curved lines for the upper and lower lips.

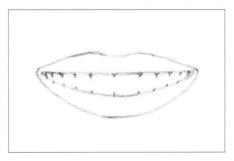

### 3 Develop the Lips and Teeth
Develop the shape of the lips. Add lines for teeth and gums. Erase unwanted marks.

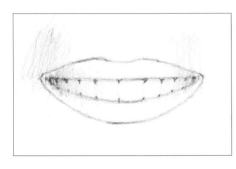

### 4 Start Shading
Start shading with lighter values. The back teeth appear darker than the front teeth and should be shaded accordingly.

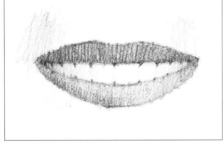

### 5 Add Shading to the Lips
Shade in the lips. The light source is from above, causing the top lip to be shadowed and slightly darker than the bottom lip.

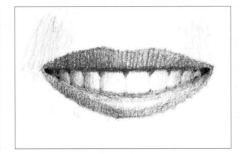

### 6 Add Darks and Highlights
Add darks to the corners of the mouth and under the top lip, and subtle darks to both lips to show form. Erase part of the lower lip to create a highlight.

# Ears

Ears are unique to each person and are a characteristic feature for identification. The size and shape of an adult's ears stay consistent until about the age of sixty, when they lengthen due to a loss of elasticity.

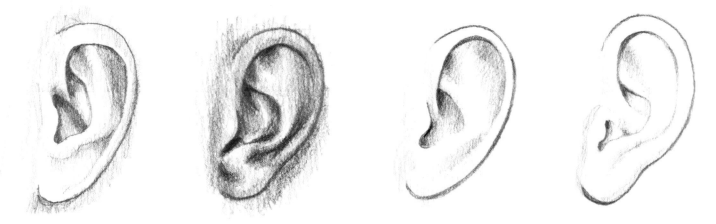

## Direct Views of the Ears
Ears have distinct edges and also subtle contours. The deepest, most recessed parts are shadowed and dark. When observed close up, they all look rather weird!

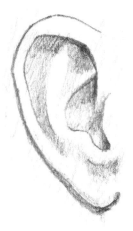
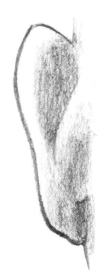
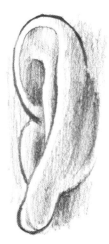

## Different Views
Viewed from different angles, ears look even odder!

## Just a Pinch
For small spots needing to be erased, pinch the end of a kneaded eraser to form a point, then press down and pull up to lift unwanted graphite.

# The Ear

## MINI-DEMONSTRATION

This mini-demo is of a middle-aged male's ear, specifically my own ear. If you meet me in public, you will be able to recognize me by my ear!

## Materials

8" × 10" (20cm × 25cm) sketch paper

2B pencil

kneaded eraser

**1 Determine the Height and Width** Sketch horizontal lines for the height and vertical lines for the width of the ear, creating a rectangle.

**2 Sketch the Outer Shape of the Ear** Sketch the outer shape of the ear, making the top portion wide and the bottom portion narrow.

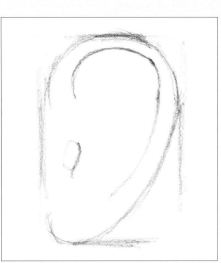

**3 Sketch the Outer Folds** Sketch the folds and edges that are closest to the outer form of the ear.

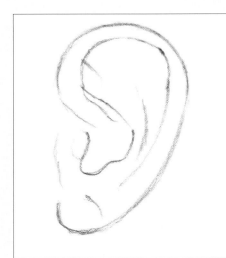

**4 Sketch Inner Folds and Erase Unwanted Lines** Sketch the folds that make up the inner region of the ear. Erase unwanted lines.

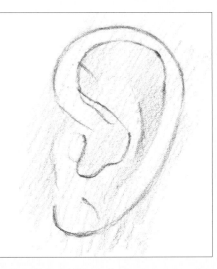

**5 Start Shading** Start shading with lighter values.

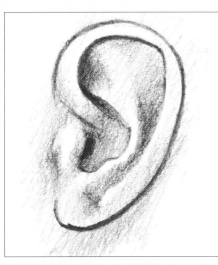

**6 Add Darks and Lighter Areas** Add darks and erase graphite to create lighter areas and give depth to the folds.

# Hair

Straight, wavy, curly, kinky, thick, thin, short and long, there are
many types of hair.

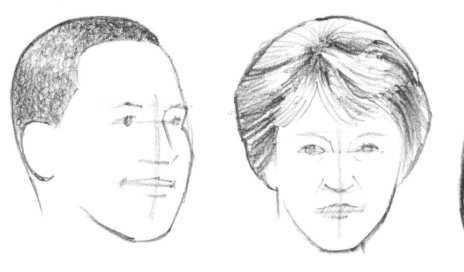

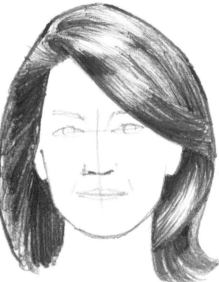

## Hairstyles

Historically regarded as a sign of a person's social status, hairstyles can be specific to eras and
cultures. Consider the beehive and the mullet. And who would Mr. T have been without his charac-
teristic Mohawk?

Draw hair using different types of pencil strokes. For short, curly hair draw with a series of small,
scribbly strokes. For straight, silky hair draw with long pencil strokes.

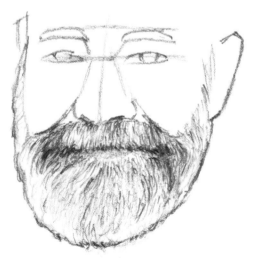

## Facial Hair

Facial hair commonly follows the contours of the face. For instance, a beard may follow the jaw
line; a mustache may follow the creases of the cheeks.

Whiskers have a coarse appearance and can be drawn with irregular pencil strokes to show
their texture.

# Hair

## MINI-DEMONSTRATION

This mini-demo is of a male teen with straight hair. Because his hair is lying flat, it has a sheen or glossy appearance.

### Materials
8" × 10" (20cm × 25cm) sketch paper

2B pencil

kneaded eraser

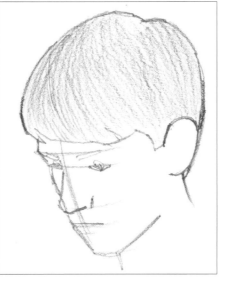

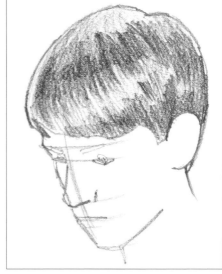

### 1 Sketch the Shape of the Head and Form the Hair
Sketch the shape of the head as a three-quarter view. Form the hairline around the contour of the head.

### 2 Erase Unwanted Lines and Add Lighter Values
Erase the line shaping the head, which would now be covered by the hair. Sketch the lighter values overall, following the direction of the hair with long pencil strokes.

### 3 Add Middle Values
Add the middle values, smoothly transitioning into the lighter values in the central area.

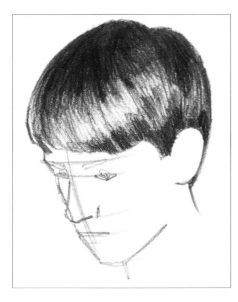

### 4 Finish With Dark Values
Add dark values and lighten some areas by gently dabbing with the kneaded eraser to give a sheen to the hair.

# Hands

Hands can add expression to a portrait, giving it emotion and personality. Hands can tell us about a person, even more than a face can by itself. Men's hands may seem bulky compared to women's hands, which are more slender.

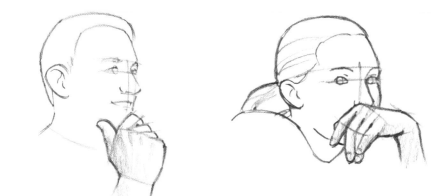

**One Shape at a Time**
When drawing hands, I first draw the basic shapes, then I add lines for the thumb and fingers, and finally I refine the form.

# The Hand
## MINI-DEMONSTRATION

With the way his hand is placed over his mouth, the subject looks as if he is talking under his breath.

**Materials**
8" × 10" (20cm × 25cm) sketch paper
2B pencil
kneaded eraser

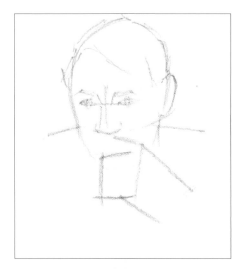

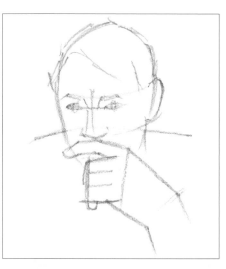

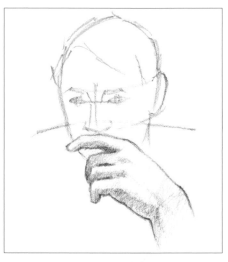

**1 Sketch the Head and the Basic Shape of the Hand**
Sketch the head from the front. Add a line for the top of the index finger, paying attention to its placement in relation to the face. Sketch the basic overall shapes of the fingers and hand.

**2 Add the Fingers and Wrist**
Sketch the individual fingers and the basic shape of the wrist.

**3 Develop the Form, Erase Lines and Add Values**
Develop the form of the fingers, hand and wrist. Erase unwanted lines and add the values.

# Costumes and Accessories

Jewelry, props and costumes included in a portrait can add another chapter to the story about the subject. If the person has an interest or hobby, consider having a prop in the drawing that suggests the interest.

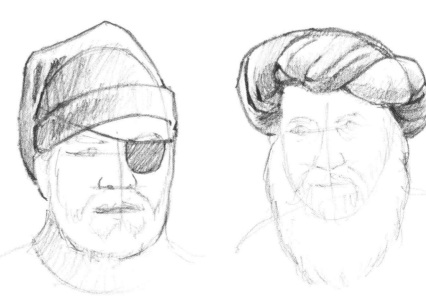

# Hats

Adding a headpiece to a portrait can speak volumes about a person's character. And they're fun!

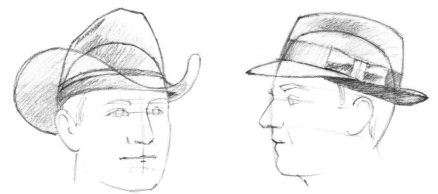
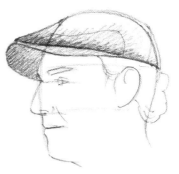

**Start With the Head**
Hats fit around the wearer's head, so it works well to sketch the head, then the form of the hat around the head.

# Baseball Cap
## MINI-DEMONSTRATION

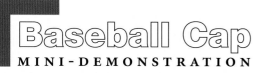

A baseball cap follows closely the top of the head with the visor coming out from the front.

**Materials**
8" × 10" (20cm × 25 cm) sketch paper

2B pencil

kneaded eraser

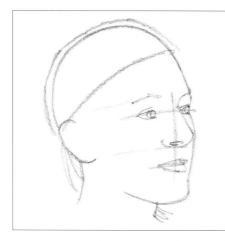
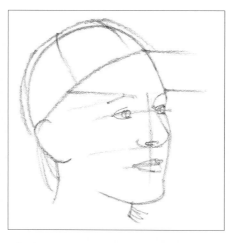

**1 Sketch the Shape of the Head and the Basic Hat Shape**
Sketch the shape of the head in three-quarter view. Form the cap part of the hat around the shape of the head.

**2 Develop the Cap and Visor**
Add horizontal lines to the front of the cap for the visor. Add the seams to the cap.

**3 Complete the Visor and Add Values**
Complete the form of the visor. Erase unwanted lines and add values.

# Eyeglasses

Glasses also give a portrait personality. People who wear glasses may want to take them off for a portrait; however, if they usually wear their glasses, the glasses might be part of their identity.

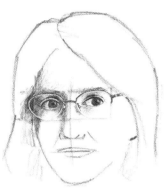

**Front View**
The lenses can change the image of the eyes behind them by casting light and shadow and sometimes distorting the elements.

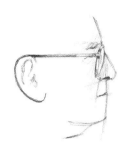

**Side View**
From the side, glasses may display their convex shape.

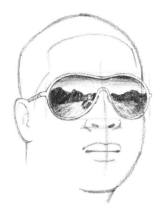

**Mirrored Lenses**
Some lenses of sunglasses act as mirrors and reflect their surroundings.

# Glasses

## MINI-DEMONSTRATION

When drawing glasses, draw a top line and a bottom line connecting both lenses. This ensures that the lenses will line up and be proportioned similarly.

> **Materials**
> 8" × 10" (20cm × 25cm) sketch paper
> 2B pencil
> kneaded eraser

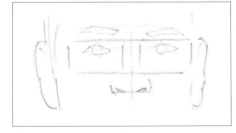

**1 Sketch the Shape of the Face and the Proportions of the Lenses**
Sketch the front view of the face around the eyes. Sketch two horizontal lines and four vertical lines as the proportions of the lenses.

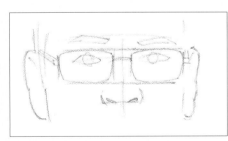

**2 Form the Shape of the Lenses and Frames**
Form the lenses and frames, rounding the sides and connecting the frames to the tops of the ears and across the nose bridge.

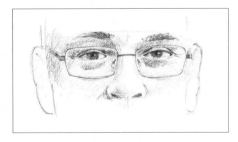

**3 Erase Unwanted Lines, Add Details and Values**
Erase unwanted lines, add details to the frames and add values to the face and glasses.

# Diversity

Every portrait has a similar foundation, yet each person is very different. Portraits can capture a story expressed through the individual features in your art.

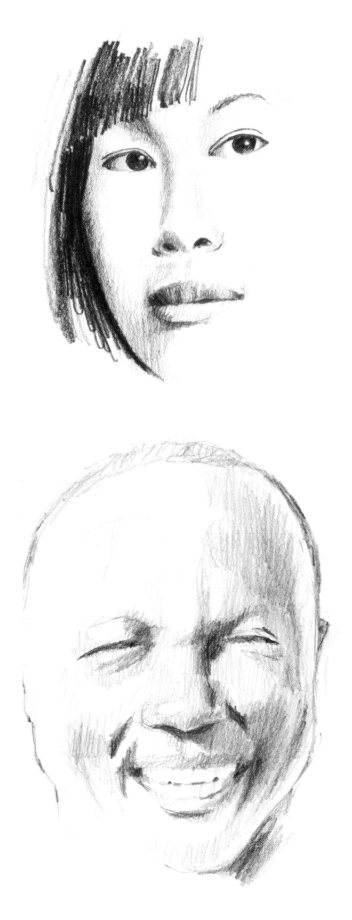

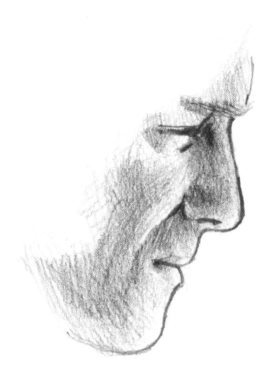

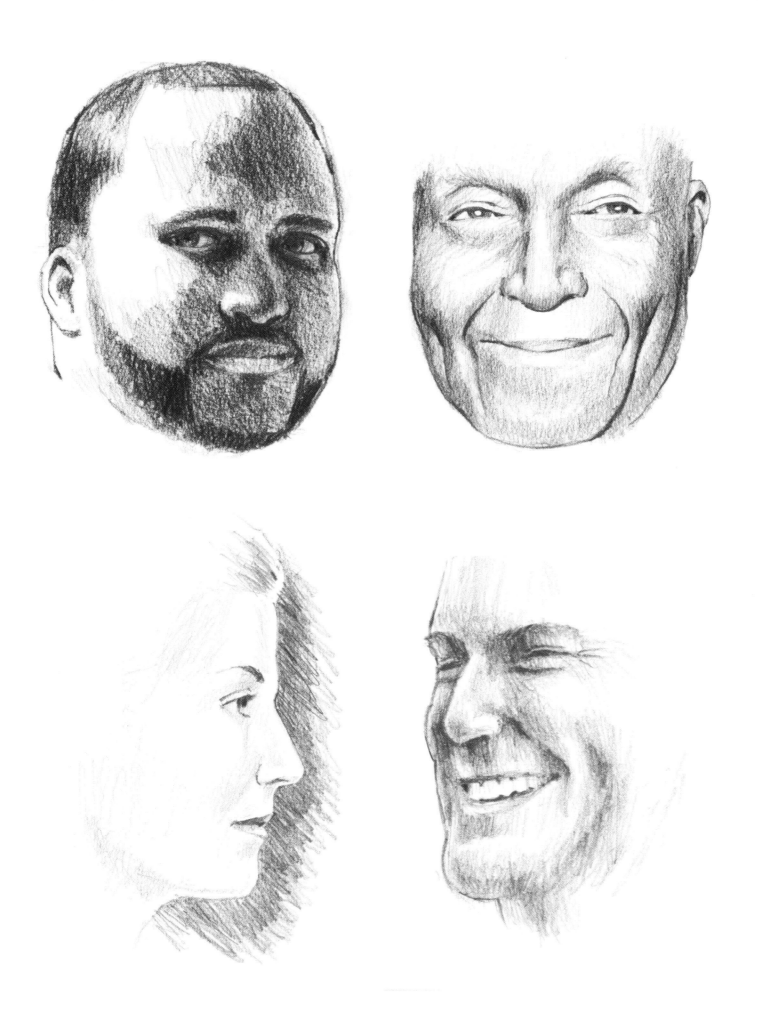

# 4 Let's Draw Portraits

If you have gone through the first chapters of this book, you are ready to tackle a demonstration. Remember to look back to previous chapters in this book if you get stuck on a specific subject.

You can do each of the demos in this book in one of two ways: you can work out the structural sketch directly onto the drawing paper, or you can draw the structural sketch on a separate piece of paper, then trace it with a lightbox or transfer it with graphite paper onto the drawing paper. The latter method reduces the amount of erasing you'll do on the drawing paper. If you work directly on the drawing paper, remember to sketch your foundation lightly so any erasing won't rough up the surface of the drawing paper.

**Refrigerator Art**

It's good to learn from other artists or to learn in a group setting. However, avoid comparing yourself to others. You are unique and so is your art.

When our children are young, we display their paintings and drawings on our refrigerator. We are proud of their art, not for its realism, but for its innocence and vitality, and, most of all, because it is an expression of themselves. As you work through these demos, try to recapture that childlike enjoyment of creating, learning and accomplishing something new.

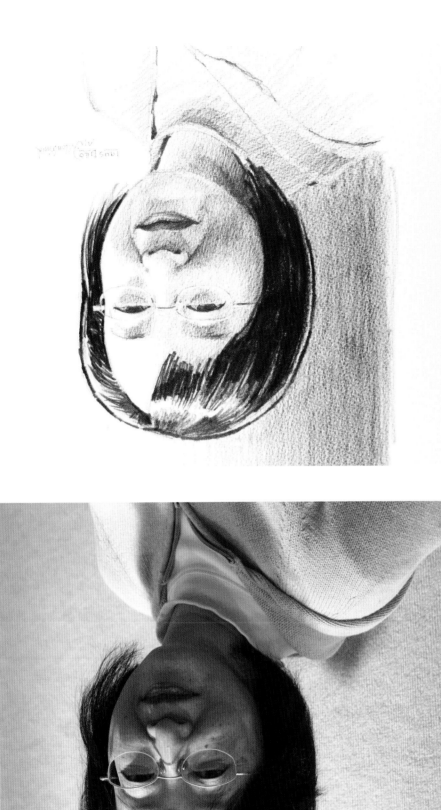

## Upside Down
Try viewing your drawing upside down with the reference photo upside down next to it. This will give you a fresh observation of the subject and push you to draw what you see rather than what you think it should look like. This is especially helpful in the latter stages of the drawing process when you add the values.

## Do a Background Check
The background of a portrait should enhance the subject and can be changed from the reference to achieve this. Remember that the person in the portrait, not the background, is the main attraction.

# Woman

Use graphite pencils on white drawing paper for this demonstration. The light source of the subject is from top right. The contrast of values in the hair, especially the rich darks created with the 8B pencil, gives it a silky appearance.

**Reference Photo**

### 1 Proportion and Sketch the Shape of the Face

With a 2B pencil, proportion the top and bottom to the sides of the face. Sketch an egg shape as the overall form of the face.

2 **Sketch the Shape of the Hair, Neck and Shoulders**
Continue using the 2B pencil to sketch the outer shape of the hair. Add the neck and shoulders. The top of the shoulders can be sketched as a single line.

3 **Sketch the Eyes, Nose and Mouth Lines and Center Line**
Sketch the horizontal lines for the placement of the eyes, bottom of the nose and the mouth. Add a vertical line to indicate the center of the face.

4 **Sketch Lines for the Brows and Lips, and Indicate the Width of the Eyes, Nose and Mouth**
Sketch horizontal lines for the brows and lips. Short vertical lines indicate the width of the eyes, base of the nose and corners of the mouth.

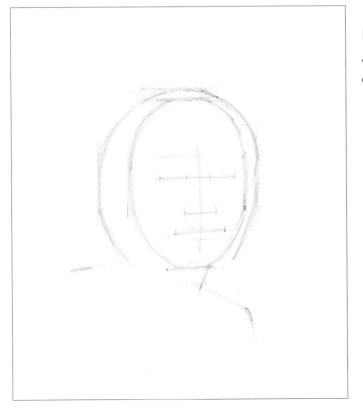

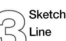

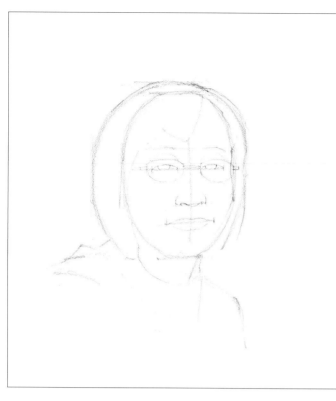

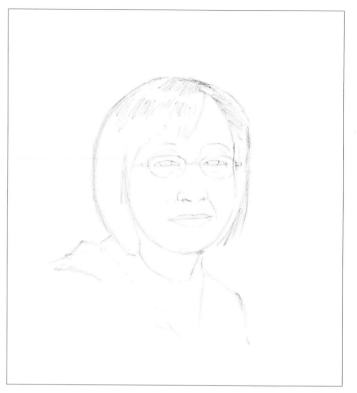

**5** **Define the Features**
Define the features including the brows, eyes, nose and lips. Develop the hair, face and clothes. Add the eyeglasses.

**6** **Erase Unwanted Lines and Sketch Lines for the Hair**
With a kneaded eraser, erase any unwanted lines. Sketch some lines for the hair, indicating highlighted regions. With the 2B pencil, transfer the image onto drawing paper if you are not already working on the drawing paper.

## Get to the Point
To create thin, detailed lines, sharpen the lead on your pencil to a point and hold your pencil upright.

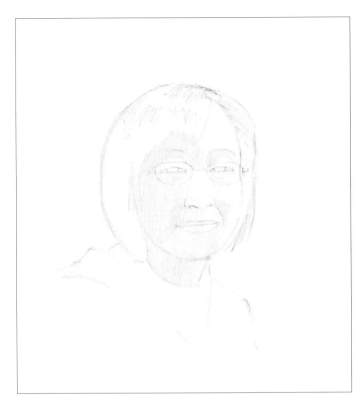

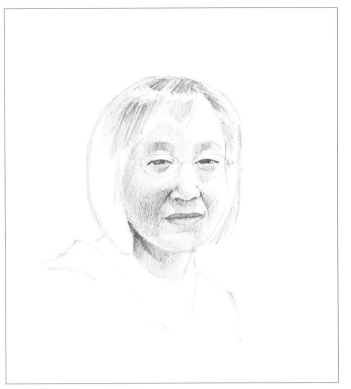

7 **Start Shading the Face and Neck**
Continue using the 2B pencil to start shading regions of the face and neck. The light source is from the top right, so the right side of the face will be lighter than the left side.

8 **Add More Shading to the Face, Neck and Hair**
Continue shading with the 2B pencil to develop the forms of the face, neck and hair.

9 **Add Shading to the Clothes and Background**
With the same pencil, add the initial shading to the clothes so they are darker on the left than on the right. Shade the left portion of the background at this stage so that the left is darker than the right, which fades to the white of the paper.

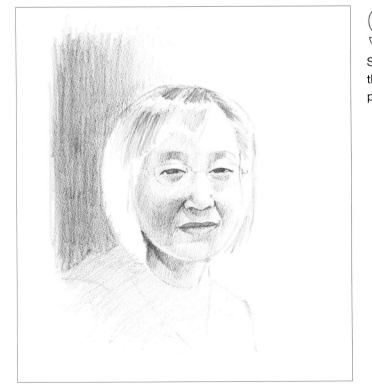

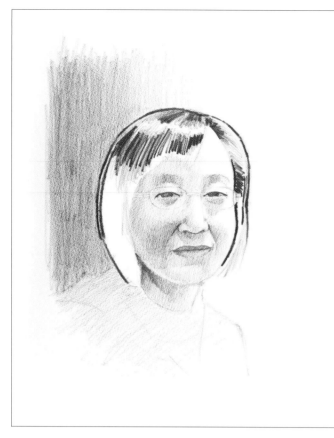

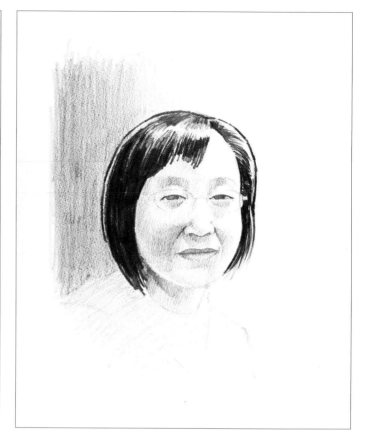

**10** **Start Darkening the Hair**
With an 8B pencil, add dark pencil strokes to the hair closest to the highlighted regions. Leave a thin light stripe around the perimeter of the hair to give the impression of reflected light on the hair.

**11** **Finish Darkening the Hair**
With pencil strokes following the direction of the hair, complete the dark regions of the hair using the 8B pencil.

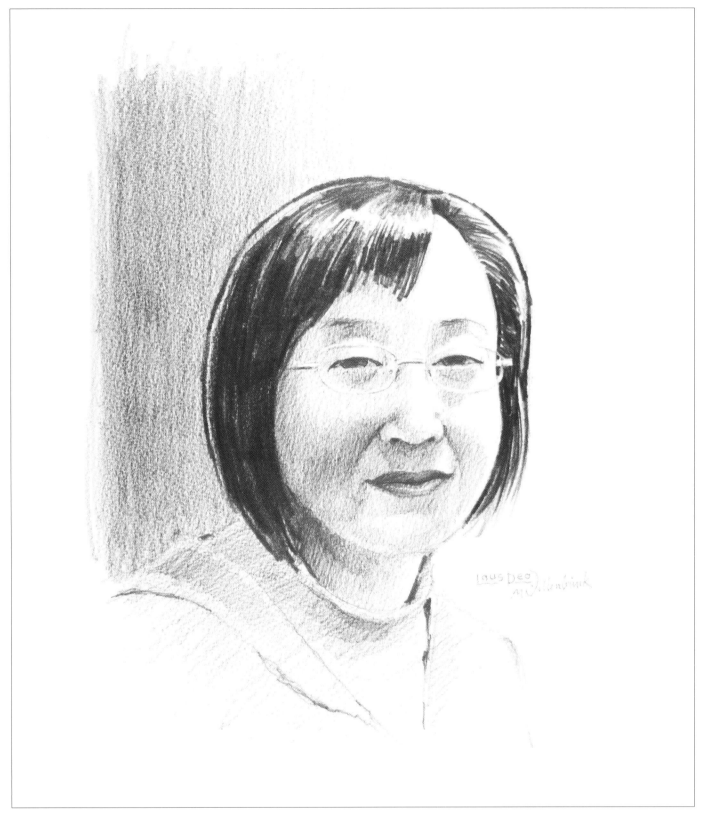

# 12 Make Adjustments and Add Details

After you have added the dark of the hair, you may find that other regions of the drawing need some darkening. With the 2B and 8B pencils, darken as needed. Finish the clothes, though these don't require much detail. Indicate the eyeglass frames by erasing along the top of the frame lines. Sign and date your portrait.

**Soleda**
Graphite pencil on drawing paper
12" × 9" (30cm × 23cm)

# Man With Beard

Interesting faces are fun to draw. The goal is to capture the depth of their personalities. The beard in this demonstration is especially interesting to draw because the drawing paper is gray and can be used as a base value for the drawing. You'll draw light areas such as the beard with white pastel pencil and dark areas with black pastel pencil.

It may be difficult to see through the gray drawing paper if you use a lightbox to trace the image. Other options are to use transfer paper or to draw from beginning to end directly onto the gray drawing paper.

## Materials

**Paper**
12" × 9" (30cm × 23cm) light gray medium-tooth drawing paper

**Pencils**
black pastel pencil
white pastel pencil

**Other Supplies**
kneaded eraser
white vinyl eraser

**Optional Supplies**
12" × 9" (30cm × 23cm) sketch paper
lightbox or transfer paper

**Reference Photo**

RELATED TOPICS

- Light Effects
- Hair and Facial Hair
- Noses

**1 Sketch the Head Shape and Lines for Basic Features**
Using a black pastel pencil, proportion the head without the beard and sketch the form. You will have to guess where the bottom of the chin is underneath the whiskers.

 **Sketch a Line for the Center of the Face and Lines for the Brows, Lips and Shoulders**
To help place the features, sketch a vertical line indicating the center of the face. Add horizontal lines for the brows and lips. Add lines for the shoulders, paying attention to where the shoulder lines are in relation to the face.

**Add More Structural Lines to Distinguish the Features**
Start to form the eyes, nose, ear, lips and shirt collar with more line work.

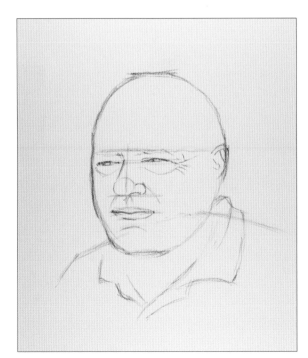

 **Define the Features**
Add more detail lines to the eyes, nose, ear and lips as well as adding facial lines.

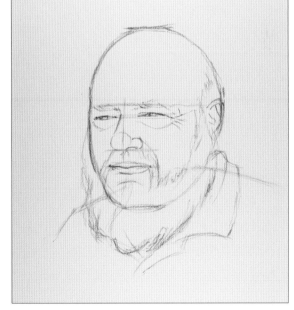

**Sketch the Placement of the Hair and Beard**
Add the brows, hair, mustache and beard. Avoid drawing in too many whiskers with the black pastel pencil (you'll draw most of the whiskers with a white pastel pencil later).

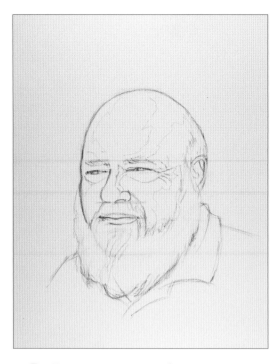

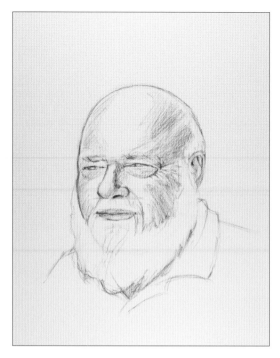

### 6 Erase Lines and Plan Shading Regions

If you started on sketch paper, transfer the image onto drawing paper. Add lines indicating regions for shading.

### 7 Start Shading

Lightly start shading regions of the face and neck including the lips and ear. Keep in mind the light is coming from the upper left and note how this affects the form and contours of the subject. To create smooth shading, place the line strokes evenly and close to each other.

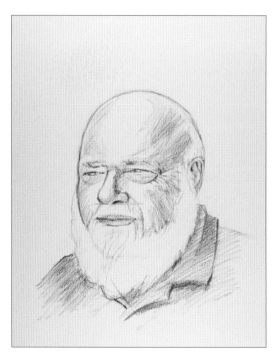

### 8 Add Shading to the Shirt

Now add shading to the shirt. For this portrait, the shirt is simple and can be drawn with little detail.

### 9 Add the Hair, Mustache and Beard

With a white pastel pencil, add the hair and whiskers. Add some dark pencil strokes with a black pastel pencil. Apply the white strokes before the black strokes because the white won't cover over the black effectively.

# 10 Add Darks and Details

Make adjustments, adding more details and darkening or lightening in some places. Sign and date your portrait.

**Donald**
Pastel pencil on gray drawing paper
12" × 9" (30cm × 23cm)

# Male Contour Drawing

This demonstration is produced as a contour drawing over a preliminary structural sketch. The line work is to be as continuous as possible. However, the pencil may be stopped, lifted and started at different places during the drawing process. The goal of this demo is not to achieve a photo-realistic representation of the subject, but to allow for a more creative interpretation.

You'll need a lightbox to see the structural sketch through the drawing paper for the contour drawing process. Use sketch paper for the structural sketch.

## Materials

**Paper**
12" × 9" (30cm × 23cm) sketch paper
12" × 9" (30cm × 23cm) medium-tooth drawing paper

**Pencils**
2B graphite pencil
4B graphite pencil

**Other Supplies**
kneaded eraser
lightbox

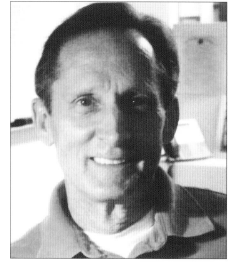

**Reference Photo**

- Contour Sketch
- Eyes
- Noses

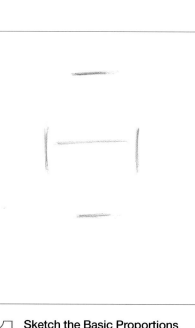

 **Sketch the Basic Proportions**
With a 2B pencil, sketch horizontal lines for the top of the head (without hair) and for the chin. Sketch a horizontal line for the eyes slightly above the halfway point between the head and chin lines. Add vertical lines for the width of the head.

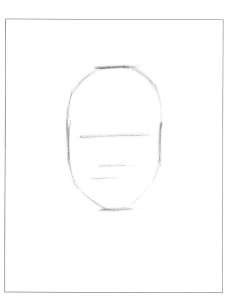

**Sketch the Head Shape and Lines for Basic Features**
Sketch the egg shape of the head and horizontal lines for the nose and mouth with the 2B pencil.

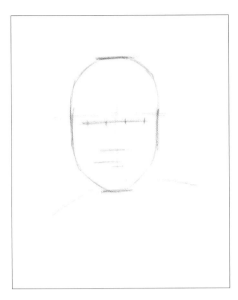

3 Sketch the Center Line and Other Lines for the Features
Sketch a vertical line for the center of the face. Add other lines for the placement of the brows, lower mouth and width of the eyes. Draw a long curved line for the shoulders.

4 Add Form to the Features
Form the eyes, ears, brows, nose, mouth and neck.

5 Add and Develop the Features
Add features such as hair and the shirt. Develop the eyes, ears and mouth by adding details.

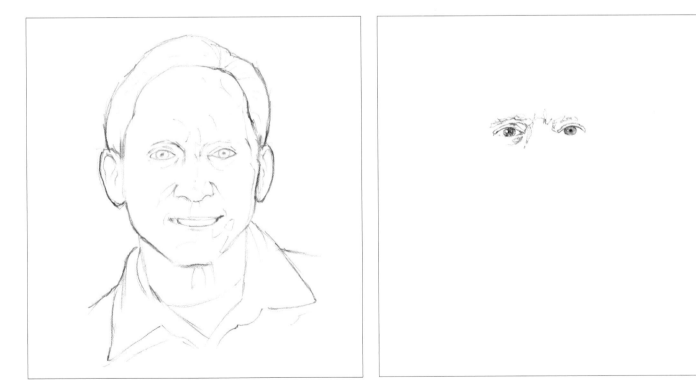

6 Erase Unwanted Lines, Refine the Features and Add Shadow Lines
Erase lines that are no longer useful. Refine and add detail to the features, and add lines to distinguish shadows.

7 Start the Contour Drawing
Tape the structural sketch to the back of a sheet of drawing paper. Illuminate the structural sketch through the drawing paper with a lightbox and start the contour drawing using the 4B pencil. Draw the left eye and begin working on the right eye.

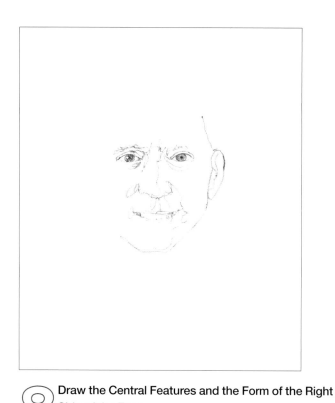

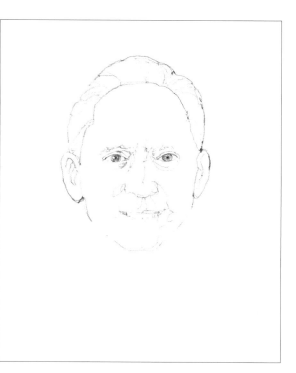

**8** Draw the Central Features and the Form of the Right Side of the Face
From the right eye, draw the form of the nose, mouth, jaw and ear, continuing with the 4B pencil.

**9** Draw the Form of the Hair and the Left Side of the Face
From the right side of the face, draw the hairline, left ear and jawline, then back up and around the top, drawing in some of the hair during the process.

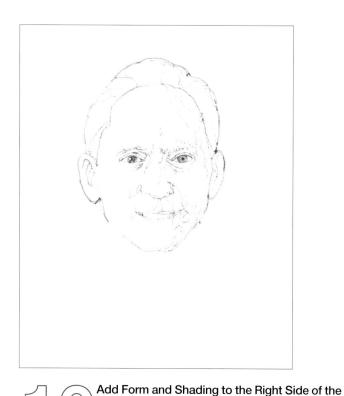

**10** Add Form and Shading to the Right Side of the Face
Continue the line, following the shapes of the face, adding form to the right side. Add vertical line work for shading. Draw around the top of the head and left side of the face and ear.

**11** Add Form to the Neck and Shirt
Continue the line work, drawing the form of the neck and shirt.

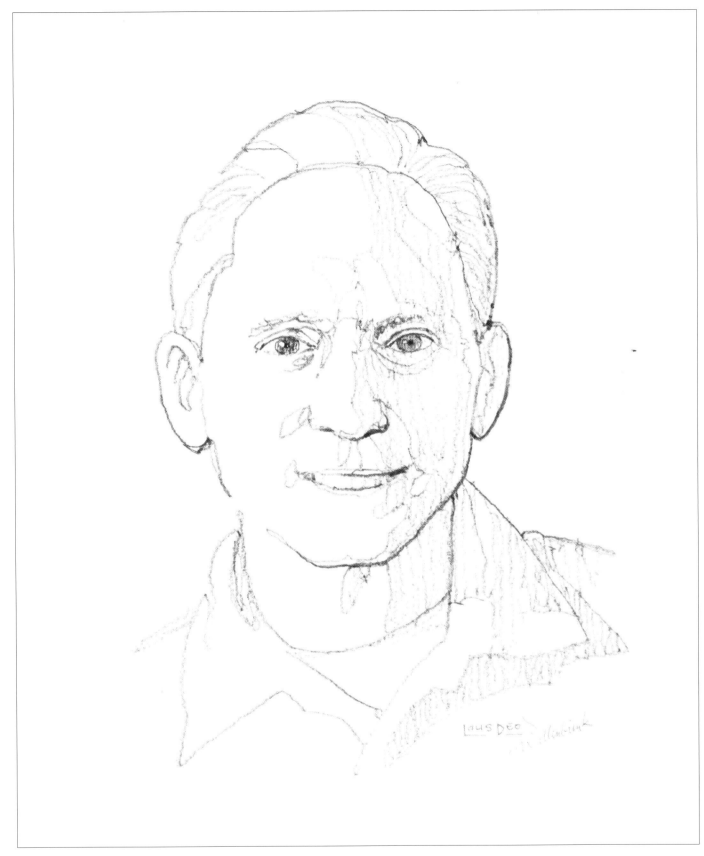

# 12

## Add Shading and Darken Some Line Work

Add shading to the neck, shirt, hair and right ear. Darken some line work to make it more shadowed, using the 4B pencil. Sign and date your portrait.

**J.V.**
Graphite pencil on drawing paper
12" × 9" (30cm × 23cm)

# Woman on Toned Paper

The paper for this portrait is gray, giving you the ability to darken with a black pastel pencil and lighten with a white pastel pencil. The light is mostly from the right, lightening the right side of the face and providing a wide range of values.

The reference photo for this portrait has a cluttered background that detracts from the subject. To remedy this, the background of the drawing will be left blank.

## Materials

**Paper**
12" × 9" (30cm × 23cm) light gray medium-tooth drawing paper

**Pencils**
black pastel pencil
white pastel pencil

**Other Supplies**
kneaded eraser

**Optional Supplies**
12" × 9" (30cm × 23cm) sketch paper
lightbox or transfer paper

**Reference Photo**

- Light Effects
- Hair
- Noses
- Lips

### 1 Proportion and Sketch the Basic Head Shape

With a black pastel pencil, proportion the height and width of the head without the hair. Sketch the basic form of the head. Add a line for the neck.

**2** Sketch Lines for the Center of the Face and the Basic Features
Sketch a vertical line for the center of the face. Add horizontal lines for the eyes, base of the nose and mouth.

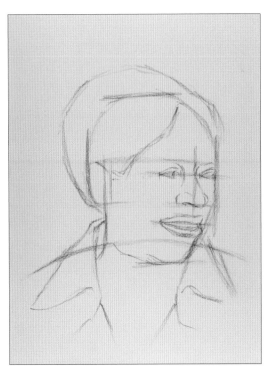

**3** Add Lines for the Shoulders, Brows, Lips and Ear
Add a curved line for the shoulders and lines for the placement of the eyebrows, lips and ear.

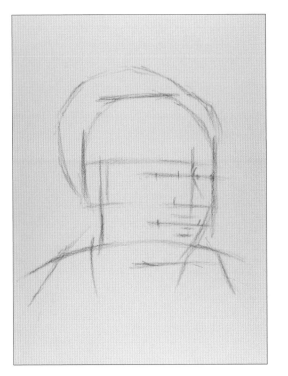

**4** Form the Hair and Shirt Collar, and Size the Facial Features
Sketch the form of the hair and the shirt collar. With short lines, plot the size of the eyes, mouth and nose, and sketch the nose bridge.

**5** Sketch the Features
Sketch the eyes, nose, mouth and ear. Add the form of the hair over the forehead and develop the chin and collar.

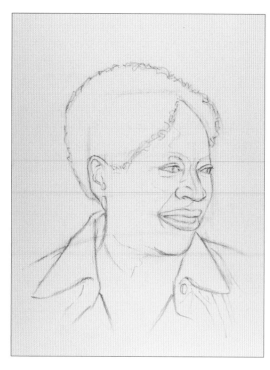

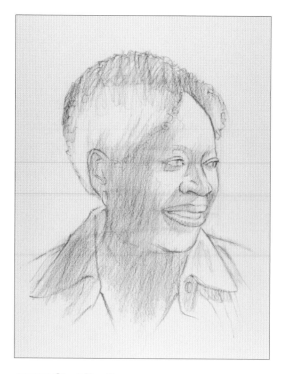

**6** Clean up and Add Details
Erase unwanted structural lines, and add detail lines to the features. If you decided to begin the drawing on a different sheet of paper, transfer the image onto the drawing paper at this stage. Add light lines indicating some of the contours of the face, neck and shirt.

**7** Start Shading
Start shading in the lightest values on the gray paper. With the primary light source coming from the upper right, the top right side of the face and many features will remain light.

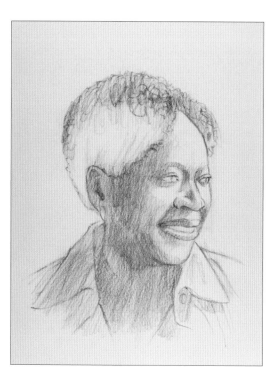

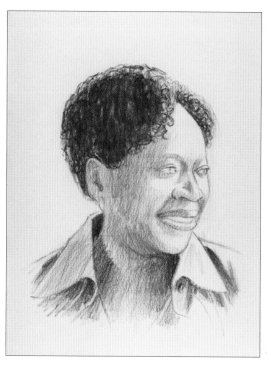

**8** Add Middle Values
Add the middle values. In many places, transition from lighter to middle values. Start adding the hair with random pencil strokes to imply the small, tight curls.

**9** Add Dark Regions
Add dark values to the hair, neck and shirt.

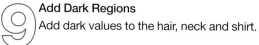

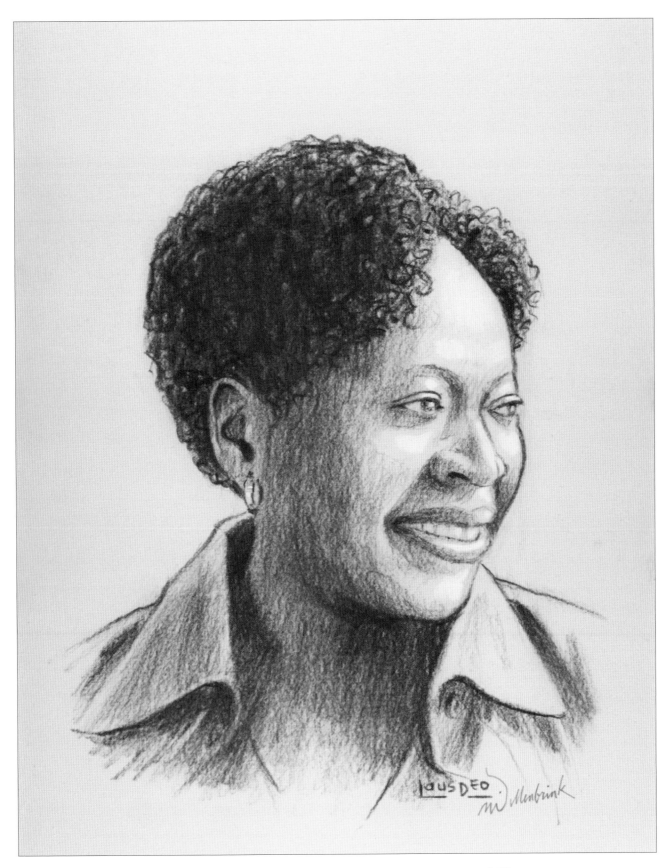

# 10 Add Details and Adjustments

Add details to the eyes, nose, lips, ear and earring. Lift some dark pastel from the hair with the kneaded eraser to suggest the curls. Use a white pastel pencil for the highlights on the face and earring. Sign and date your portrait.

**C.W.**
Pastel pencil on gray drawing paper
12" × 9" (30cm × 23cm)

# Baby

Not only is the placement of the facial features different for babies than for adults, but the overall form and proportions of the head are also different. Notice that the widest part of the head is only about one third of the way down from the top of the head.

The lighting is coming just left of center, creating subtle value transitions.

## Materials

**Paper**
12" × 9" (30cm × 23cm) medium-tooth drawing paper

**Pencils**
2B graphite pencil

4B graphite pencil

**Other Supplies**
kneaded eraser

**Optional Supplies**
12" × 9" (30cm × 23cm) sketch paper

lightbox or transfer paper

- Child Proportions
- Ears

**Reference Photo**

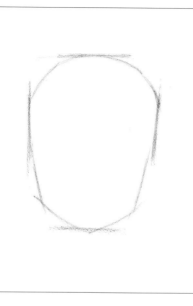

### 1 Proportion and Sketch the Shape of the Head

With the 2B pencil, proportion the top, bottom and sides of the head. Form the basic shape of the head, following the proportion lines.

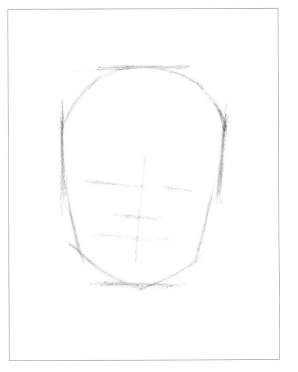

**2** Sketch the Placement Lines for the Features and the Center of the Face
Continuing to use the 2B pencil, sketch horizontal lines, slightly angled, for the placement of the eyes, nose and mouth. Sketch a vertical line, slightly angled, for the center of the face.

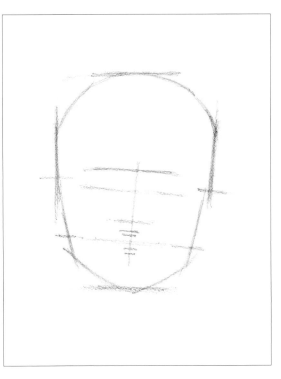

**3** Sketch Lines for the Brows, Lips and Ears
Sketch placement lines following the same angles as the previous lines for the brows, lips and ears. Notice that the tops of the ears line up below the brows and the bottoms of the ears line up with the mouth.

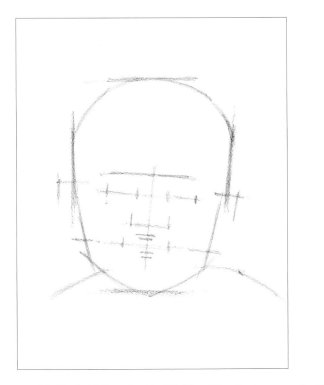

**4** Sketch Lines for the Width of the Features and a Line for the Shoulders
Sketch short lines to indicate the width of the eyes, nose, mouth and ears. Sketch a line for the position of the shoulder.

**5** Define the Features
Define the brows, eyes, nose, mouth, chin and ears. Add the shirt and collar.

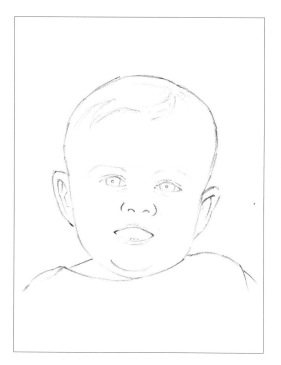

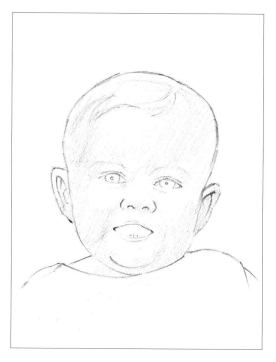

**6** Add Details and Erase Unwanted Lines or Transfer Image

Add details including hair, eyelid creases, folds of the ears and two cute, little bottom teeth. Erase unwanted lines if working directly on the drawing paper, or trace or transfer the image onto drawing paper using the 2B pencil.

**7** Start Shading With the Lighter Values

Continuing with the 2B pencil, start shading the lighter regions. Notice that the light source is from above, left of center, making the tops of the forehead, cheeks and nose some of the lightest places on the face.

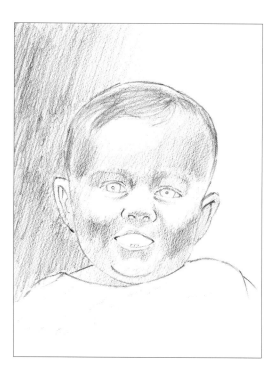

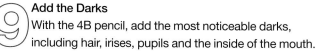

**8** Add Middle and Background Values

Add the middle values to the subject, using the same pencil. Add values to the background, shading the area so there are middle values on the left, gradually lightening to the white of the paper on the right.

**9** Add the Darks

With the 4B pencil, add the most noticeable darks, including hair, irises, pupils and the inside of the mouth.

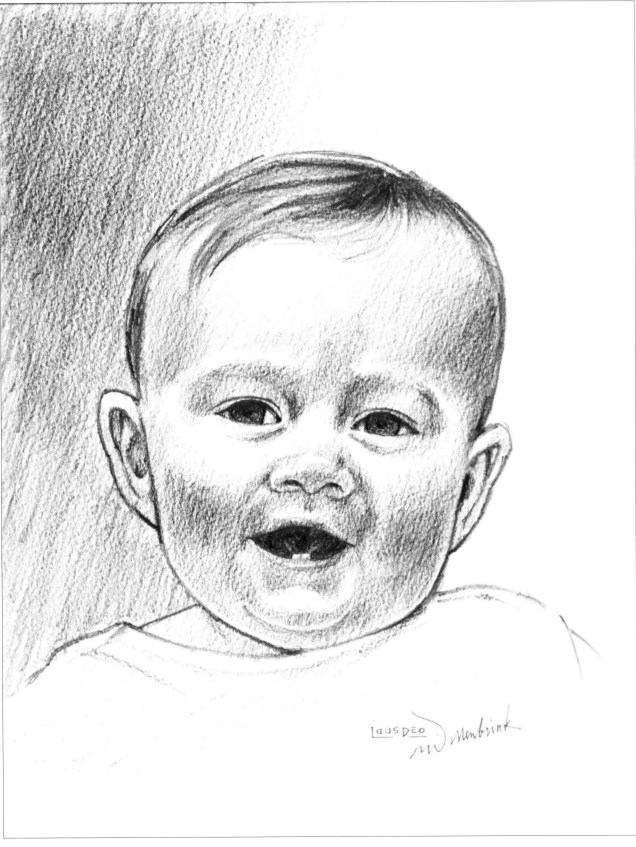

# 10 Make Adjustments and Add Details

Make adjustments, including darkening some areas with both 2B and 4B pencils. Lighten some areas if needed with the kneaded eraser, and add details. Sign and date your portrait.

**Eli**
Graphite pencil on drawing paper
12" × 9" (30cm × 23cm)

# Costumed Woman

Practice makes perfect! The more you practice drawing portraits, the better you will become. After practicing on your friends and family, you may feel you have run out of models for your portraits. Consider taking photos of people when you are out and about. This portrait is of an actress at a historical festival.

**Reference Photo**

## Materials

**Paper**
12" × 9" (30cm × 23cm) medium-tooth drawing paper

**Pencils**
2B graphite pencil

4B graphite pencil

6B graphite pencil

**Other Supplies**
kneaded eraser

**Optional Supplies**
12" × 9" (30cm × 23cm) sketch paper

lightbox or transfer paper

• Hats
• Noses
• Ears
• Eyes
• Mouths

### 1 Proportion and Sketch the Shape of the Head

With the 2B pencil, proportion the top, bottom and sides of the head with horizontal and vertical lines. Start to form the shape of the head using the proportion lines for guidance.

**2** Sketch Placement Lines for the Basic Features and the Center of the Face
Continuing with the 2B pencil, sketch horizontal lines for the placement of the eyes, nose and mouth. Add a vertical line for the center of the face.

**3** Sketch Placement Lines for the Remaining Features
Sketch horizontal placement lines for the brows and lips, and a vertical line for the ear. Sketch lines for the basic form of the hat and lines for the neck.

**4** Develop the Features and Shoulders
Sketch short vertical lines for the width of the eyes and mouth. Form the nose and side of the mouth. Sketch a curved line for the shoulders.

**5** Define the Features
Define the eyes, brows, lips, ear and hair.

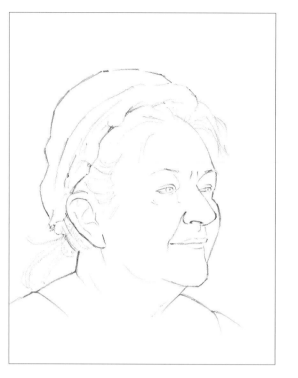

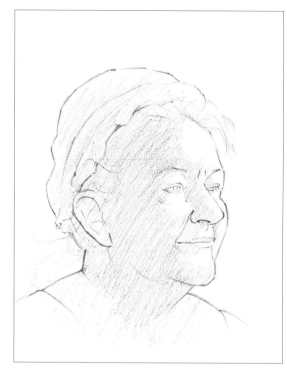

**6** Add Details and Erase Unwanted Lines or Transfer the Image

With the 2B pencil, add details to the features including the hair and hat. Erase unwanted lines if you are working directly on the drawing paper, or trace or transfer the structural sketch onto drawing paper.

**7** Start Shading With Lighter Values

Start shading the lighter regions with a 2B pencil. The light source is coming from the top right, making the right side of the face lighter than the left side.

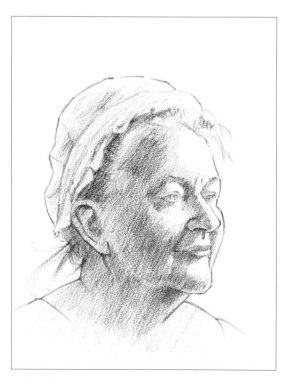

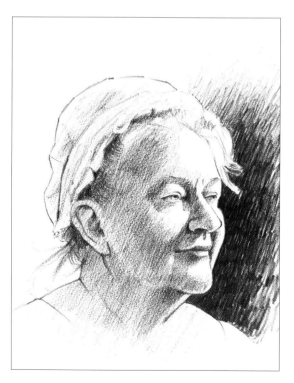

**8** Add Middle Values

Add middle values to the subject with a 4B pencil.

**9** Add Darks and Values to the Background

With a 6B pencil, add dark values to the subject and to the right side of the background.

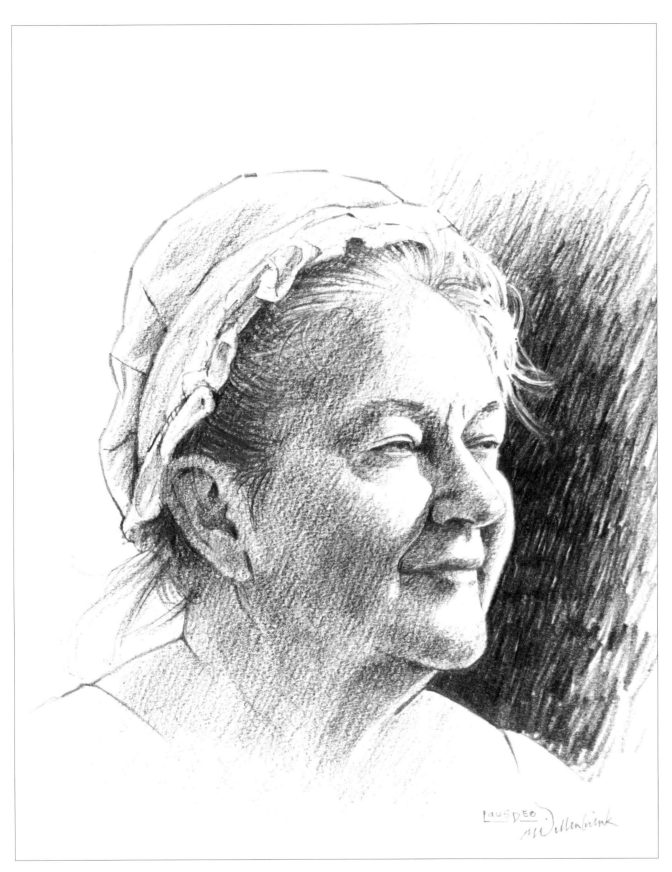

# 10 Make Adjustments and Add Details

With the 2B, 4B and 6B pencils, make adjustments and add details to features such as the hair and the hat. Use the kneaded eraser to lighten if needed. Sign and date your portrait.

**Rebecca**
Graphite pencil on drawing paper
12" × 9" (30cm × 23cm)

# Man in Profile

The light source for this subject is primarily coming from the upper left, causing the face to be lighter than the back of the head.

Use charcoal pencil to obtain the values in this demo. Charcoal lines can be blended using facial tissue and a blending stump to create smooth shading and transitions, but the medium can also cause unintentional smearing. Place a slip sheet under your hand to avoid unwanted smears and fingerprints.

**Reference Photo**

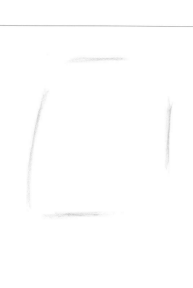

## Materials

**Paper**
12" × 9" (30cm × 23cm) medium-tooth drawing paper

**Pencils**
2B charcoal pencil
2B graphite pencil

**Other Supplies**
blending stump
facial tissue
kneaded eraser
slip sheet

**Optional Supplies**
12" × 9" (30cm × 23cm) sketch paper
lightbox or transfer paper

- Eyeglasses
- Facial Hair
- Ears
- Noses

**1  Sketch the Basic Head Proportions**
With a 2B graphite pencil, sketch the height and width proportions of the head on a sheet of sketch paper. The curved line for the left side will be the basis for the profile. You can make this line with a 2B charcoal pencil directly onto the drawing paper if you choose not to trace the structural sketch onto the drawing paper at a later stage.

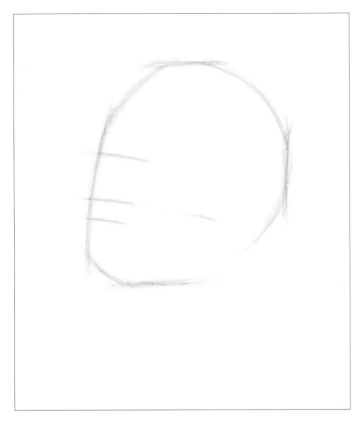

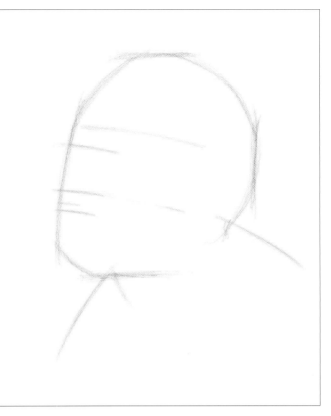

 **Sketch the Head Form and Lines for the Features**
Sketch the overall form of the head, following the proportions previously determined. Add lines for the placement of the eye, nose and mouth.

**Sketch Lines for the Brow, Upper Lip, Neck and Shoulders**
Sketch lines for the placement of the brow and upper lip. Sketch lines for the neck and shoulders.

**Define the Profile Features and Add the Eye and Ear**
Define the profile of the face by shaping the forehead, brow, nose, lips and chin. Sketch the eye as a triangle shape and form the ear.

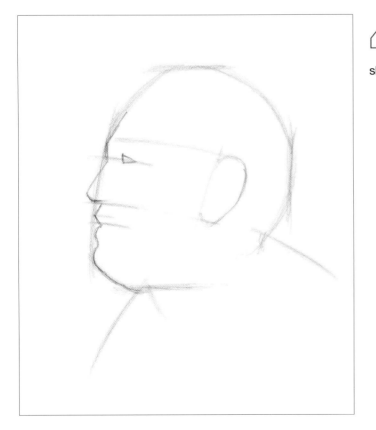

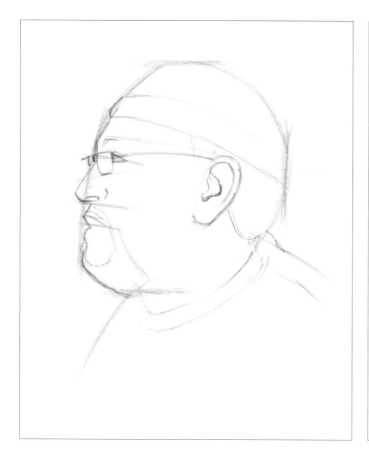

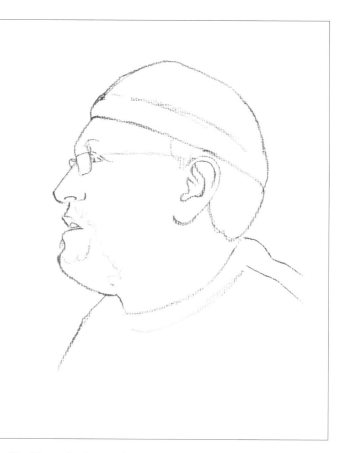

**Add and Define the Structural Features**
Add and define the features that make up the structural sketch including the eye, nose, top lip, ear, eyeglass frames, goatee, hat and shirt.

**Trace the Image Onto Drawing Paper**
Using a lightbox, trace the necessary lines of the image onto drawing paper with a 2B charcoal pencil, or erase any unwanted lines if you chose to work directly on the drawing paper with the 2B charcoal pencil.

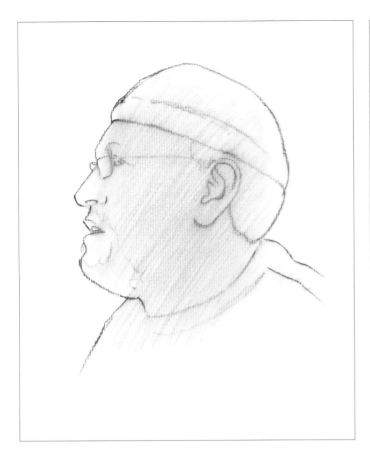

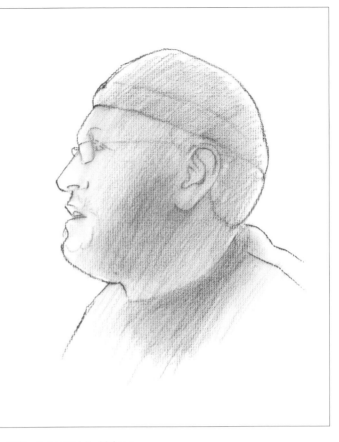

### 7 Add Light Values Over the Image

With light side-by-side strokes of the 2B charcoal pencil, add values to the image. The pencil strokes can be smeared with a facial tissue to soften the values. You'll make the highlights by lifting off the charcoal with a kneaded eraser at a later stage.

### 8 Add Middle Values

Add the middle values with more charcoal pencil strokes, with the left side of the face being somewhat lighter because of the light source. Lightly smear the charcoal with a tissue. Remember to rest your hand on a slip sheet to avoid unwanted smears and fingerprints.

### Slip a Sheet Under It

Remember to use a slip sheet under the hand you're drawing with to avoid unintentionally smearing your drawing as you are working.

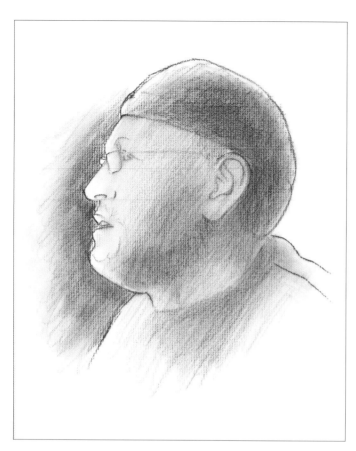

### Add Darker Values

9 Add darker values to the face, hat and left side background. Smear with a tissue.

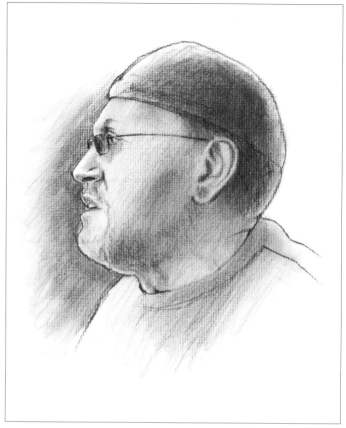

### Add Detailed Darks

10 Add detailed darks to areas including sunglasses, eye, ear and mouth. For more detailed blending of values, use the blending stump.

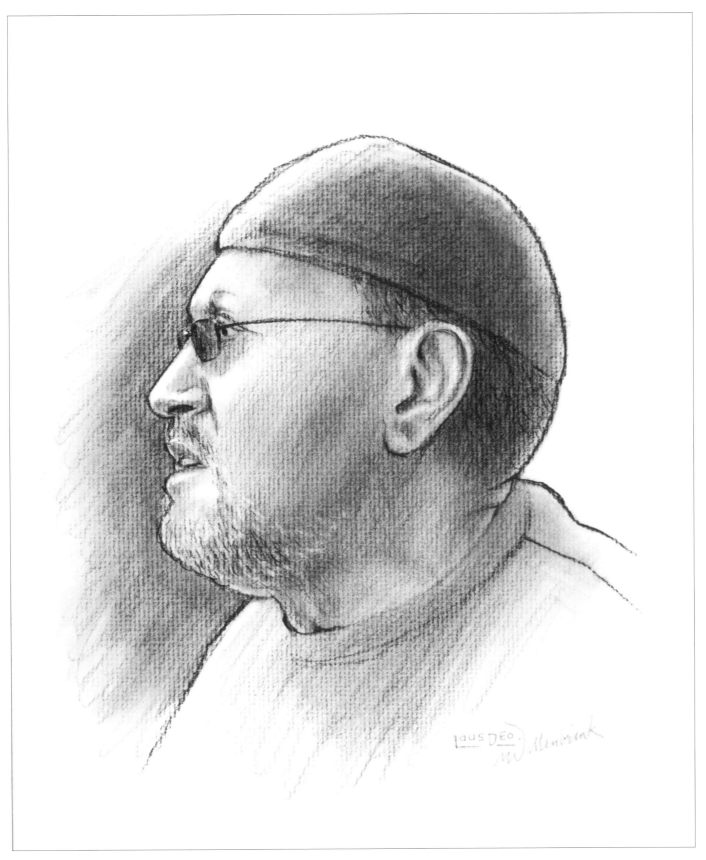

**11** **Add Details and Make Adjustments**
Add final details and make adjustments, including removing graphite with a kneaded eraser to make highlights and lighter whiskers. Darken some areas and make some dark whiskers. Sign and date your portrait.

**Earl**
Charcoal pencil on drawing paper
12" × 9" (30cm × 23cm)

# Mother and Baby

Children's heads are generally smaller than those of adults. However, in this photo the baby's and mother's heads appear to be about the same size. The features and their placement will help to express their ages.

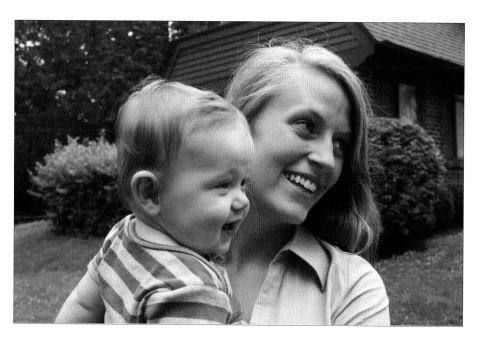

**Reference Photo**

## Materials

**Paper**
9" × 12" (23cm × 30cm) fine tooth drawing paper

**Pencils**
2B graphite pencil
4B graphite pencil

**Other Supplies**
kneaded eraser

**Optional Supplies**
9" × 12" (23cm × 30cm) sketch paper
lightbox or transfer paper

- Child Proportions
- Eyes
- Hair
- Teeth
- Ears

**1 Sketch the Basic Proportions and the Shape of the Baby's Head**
Using a 2B pencil, sketch the proportions for the width of the baby's head with vertical lines and the height of the head with horizontal lines. Form the basic head shape with proportion lines. Place the baby's head left of center on the paper to allow room for the mother's head.

 **Sketch the Basic Proportions and the Shape of the Mother's Head**
Continuing with the 2B pencil, sketch a vertical line for the placement of the forehead and horizontal lines for the height of the head without the hair. Form the basic head shape following the proportion lines. Pay attention to the placement of the mother's head in relation to the baby's head.

 **Sketch Placement Lines for the Basic Features**
Sketch lines for the center of the faces and for the placement of the eyes, base of the noses and mouths. Remember, babies are proportioned much differently than adults.

**Sketch More Placement Lines**
Sketch lines for the brows, lips and the baby's ear. Add lines for the shoulders.

**Sketch Lines for the Width of the Facial Features**
Place short lines to indicate the width of the eyes, noses and mouths.

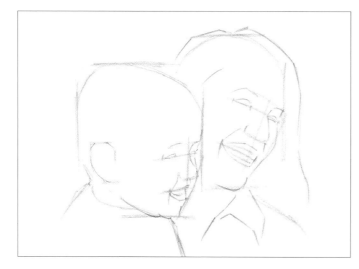

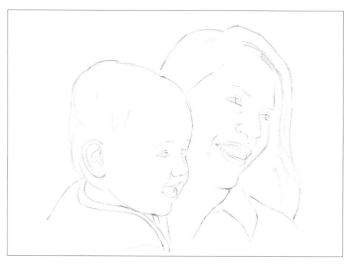

**Form the Features**

Form the facial features following the placement lines. Form the hair, shirt collars and facial shapes.

**Add Detail Lines and Trace or Transfer the Images or Erase the Unwanted Lines**

With the 2B pencil, add detail lines to the features. Trace or transfer the image onto drawing paper, or erase the unwanted lines if you chose to work directly on the drawing paper.

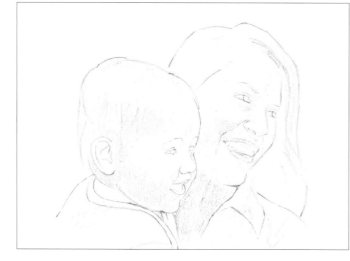

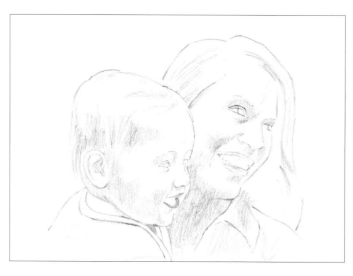

**Start Adding Values**

Start adding values over the baby and mother with the 2B pencil. Leave some of the areas white for the highlights.

**Continue With Middle Values**

Add middle values to the baby and mother, using the same pencil.

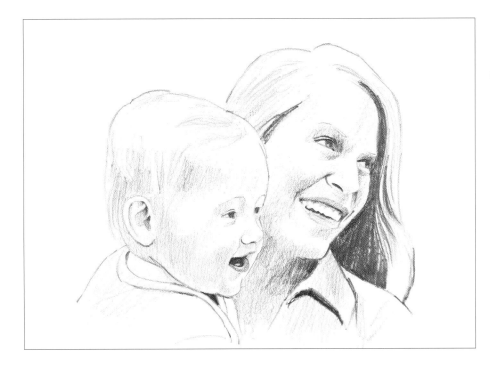

**10** Start Adding Darks
With the 4B pencil, add darks to the eyes and shadowed regions.

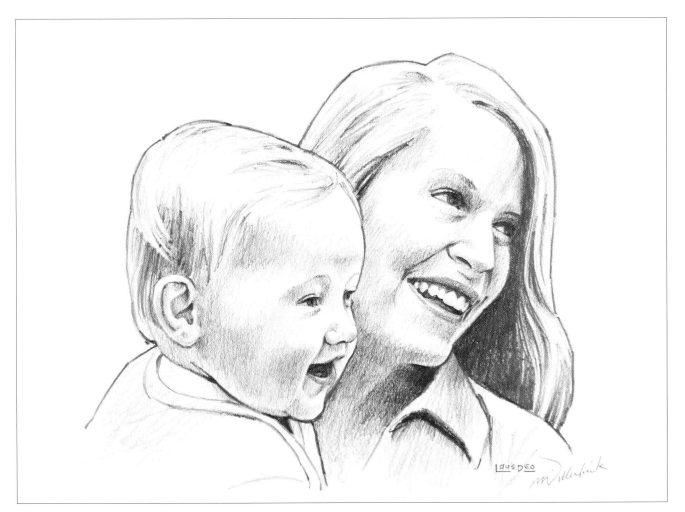

**11** Finish With Details and Adjustments
Add details with both 2B and 4B pencils. Lighten some areas with a kneaded eraser. Sign and date your portrait.

**Mother and Baby**
Graphite pencil on drawing paper
9" × 12" (23cm × 30cm)

# Close-up Portrait

I find this view of the subject more challenging to draw than a direct profile but less challenging than drawing the full head because part of the head is cropped out of the picture. This draws more attention to the features than to the overall form. Though the subject is interesting, the lighting of the photograph makes the face look flat and could be improved upon. For this reason, I will broaden the range of values in the face to add more depth to the drawing.

The man who modeled for this demonstration was a personality at an outdoor historical reenactment. Such events are great places to photograph people in period costumes.

**Reference Photo**

## Materials

**Paper**
9" × 12" (23cm × 30cm) fine-tooth drawing paper

**Pencils**
2B graphite pencil

4B graphite pencil

8B graphite pencil

**Other Supplies**
kneaded eraser

**Optional Supplies**
9" × 12" (23cm × 30cm) sketch paper

lightbox or transfer paper

• Hats
• Noses
• Lips
• Ears

**1 Sketch Placement Lines**
With a 2B pencil, sketch a slightly curved vertical line for the right side of the face. Sketch curved diagonal lines for the brows and the base of the chin, then a line halfway between for the base of the nose. Add lines for the eyes and mouth.

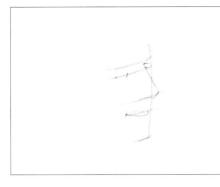

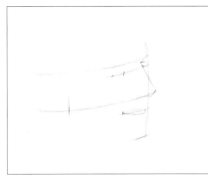

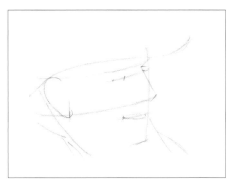

### 2 Place and Form the Basic Features

Place the eyes, and form the nose and mouth. Sketch basic shapes for the placement of the eyes on the previously drawn line. Start to form the nose and mouth.

### 3 Place the Ear

Continue the lines from the brows and base of the nose around the side of the face. Add a vertical line across the line coming from the base of the nose. The distance between this short line and the right vertical face line is equal to the distance between the brow line and the chin line.

### 4 Form the Ear, Hat, Shirt and Vest

Sketch the form of the ear, using the previous lines for its placement. Add lines for the hat, shirt and vest.

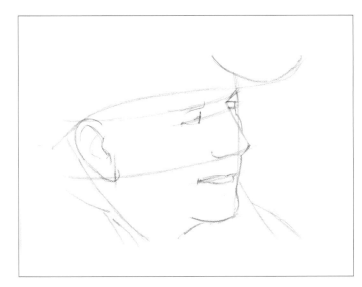

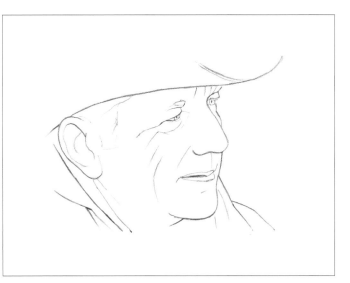

### 5 Add Lines to the Features

Add lines to the ear, brows, eyes and lips. Form the right side of the face, nose and chin. Sketch the curved line of the hat.

### 6 Add Detail Lines and Transfer the Image or Erase Unwanted Lines

With the 2B pencil, add detail lines to the eyes and brows. Sketch the wrinkles and sideburn. Trace or transfer the image onto drawing paper, or erase unwanted lines if working directly on the drawing paper.

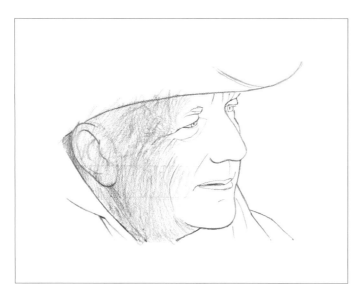

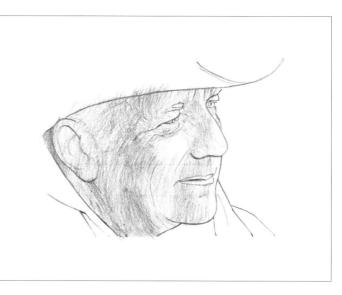

**7** Start Adding Values
With the 4B pencil, start adding the middle values. The direction of the pencil strokes may follow the creases and lines of the face.

**8** Continue Adding Middle Values
Continue covering the face with middle values, going lighter or darker in some areas. There is more light on the right side of the face than on the left. This will affect the values of the individual features.

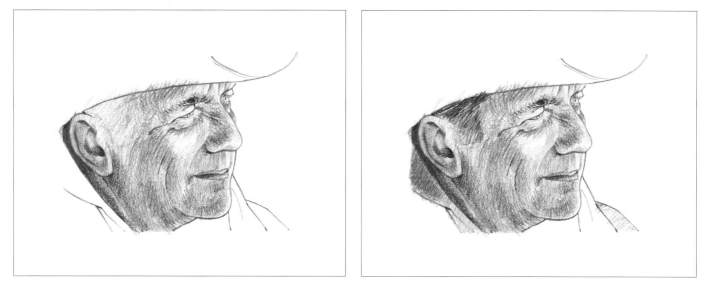

**9** Start Adding Darks to the Face
Add darks to the face with the 4B and 8B pencils. Some places such as the neck area and behind the ear need to be very dark.

**10** Add the Shirt and Sideburn
Add values of the shirt and sideburn with a 4B pencil. To draw the individual hairs, sharpen the pencil to a fine point.

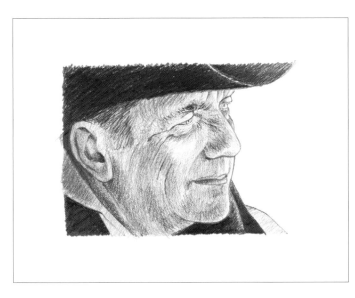

## 11 Add the Hat and Vest
Add the rich darks of the hat and vest with the 8B pencil.

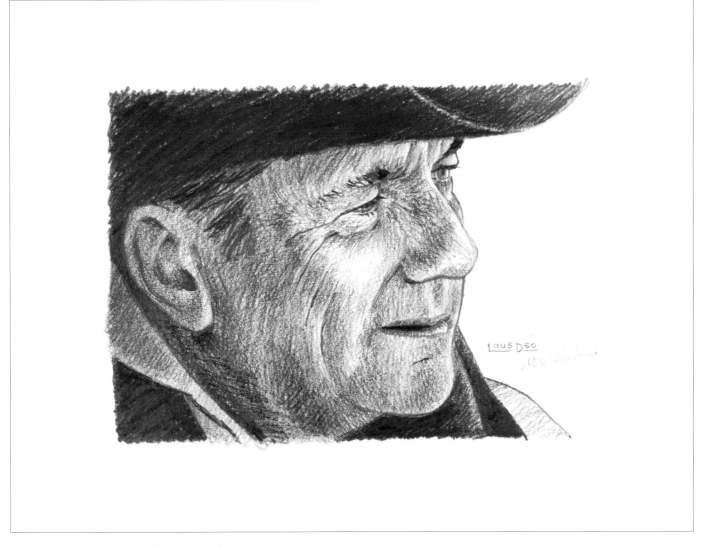

## 12 Finish the Details and Adjustments
Add details to the eyes. Make adjustments by lightening some areas with a kneaded eraser and darkening other areas with the 2B, 4B and 8B pencils. Sign and date your portrait.

**E.B.**
Graphite pencil on drawing paper
9" × 12" (23cm × 30cm)

# Male Teen With Hat

The lighting for this subject is coming almost evenly from both the right and the left. Notice how dark the lower left portion of the face is compared to the rest of the face. Including the hand gives more personality to the subject.

**Reference Photo**

## Materials

**Paper**
12" × 9" (30cm × 23cm) fine-tooth drawing paper

**Pencils**
2B graphite pencil
4B graphite pencil
8B graphite pencil

**Other Supplies**
kneaded eraser

**Optional Supplies**
12" × 9" (30cm × 23cm) sketch paper
lightbox or transfer paper

- Hands
- Hats
- Lips
- Ears
- Noses

**1** **Sketch the Basic Proportions and the Shape of the Head**
With a 2B pencil, sketch the proportions for the width of the head with vertical lines and the height of the head with horizontal lines. The head should be placed to the upper left on the paper to allow room for the hand and shoulder. The line for the top of the head is placed just below the top of the hat. Form the basic head shape using the proportion lines.

**2 Sketch Placement Lines for the Basic Features**
Continuing with the 2B pencil, sketch a vertical line, slightly angled, for the center of the face. Sketch horizontal lines that are slightly angled for the eyes, base of the nose and mouth.

**3 Sketch More Placement Lines**
Sketch horizontal lines for the placement of the brows, lips and ear. Add vertical lines for the width of the ear. Add lines for the neck and shoulders.

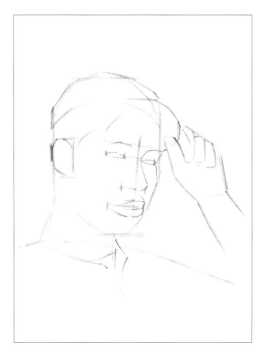

**4 Sketch Lines for the Hat, Features, Hand and Wrist**
Sketch a curved line for the lower portion of the cap and a short vertical line for the placement of the brim. Use short vertical lines to indicate the width of the eyes, nose and mouth. Sketch lines for the basic shapes of the hand and forearm, paying attention to the relationship of the hand to the brim of the hat.

**5 Form the Features**
Form the facial features including the brows, eyelids, nose, lips, hairline and the side of the face. Form the top of the hat and brim. Add the fingers and then collars to the undershirt and outer shirt.

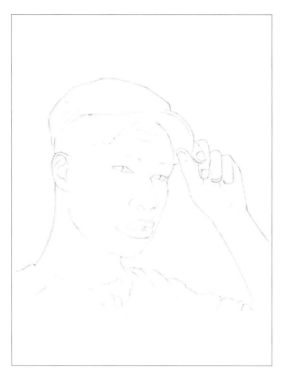

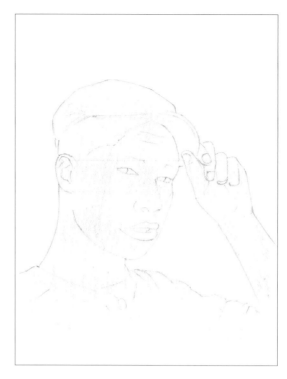

6 Add Detail Lines and Transfer the Image or Erase Unwanted Lines

With the 2B pencil, add detail lines to all of the features. Trace or transfer the image onto drawing paper, or erase unwanted lines if working directly on drawing paper.

7 Start Adding Values

With a 4B pencil, start adding lighter values to the subject. Keep the background white. The hat will be drawn darker than it is in the photo and without the plaid pattern.

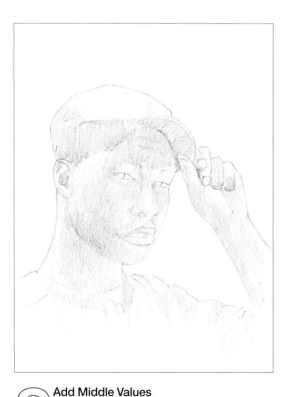

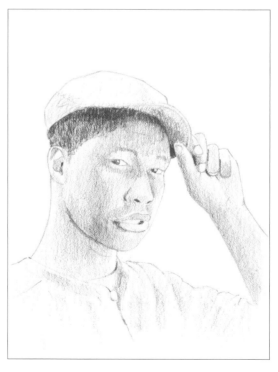

8 Add Middle Values

With the same pencil, add the middle values to give depth to the subject. At a later stage you can lighten some areas with a kneaded eraser.

9 Start Adding Darks

With the 8B pencil, start adding darks to the face, hand, arm and shirt.

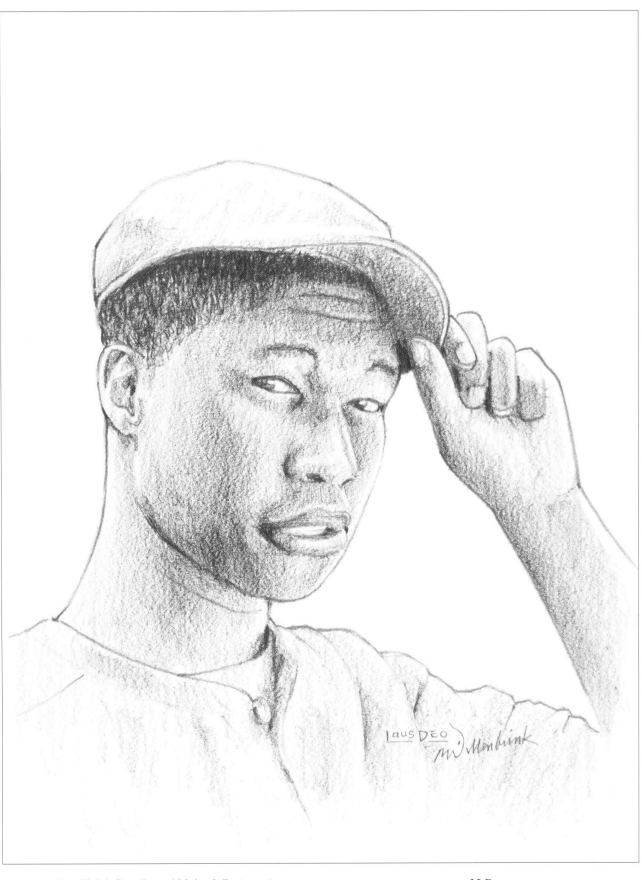

## 10 Finish Details and Make Adjustments

Add details to the features using both 4B and 8B pencils. Lighten some of the areas with a kneaded eraser. Sign and date your portrait.

**M.C.**
Graphite pencil on drawing paper
12" × 9" (30cm × 23cm)

# Little Girl in Pastel

For this drawing, I selected a gray paper with three pastel pencils, one pencil lighter and two darker than the paper. When working with pastel pencils, build up values slowly. It can be difficult to place one pastel over another, especially a white pastel over a darker pastel, so be thoughtful in their use.

I sketched the structural drawing on sketch paper and transferred it to the drawing paper. However, you may choose to work out the structural sketch directly on the drawing paper.

The light source is from above, slightly to the right.

## Materials

**Paper**
12" × 9" (30cm × 23cm) medium gray, medium-tooth drawing paper

**Pencils**
black pastel pencil
light gray pastel pencil
medium gray pastel pencil

**Other Supplies**
kneaded eraser

**Optional Supplies**
2B graphite pencil
12" × 9" (30cm × 23cm) sketch paper
lightbox or transfer paper

- Child Proportions
- Hair
- Hands
- Noses
- Eyes
- Mouth

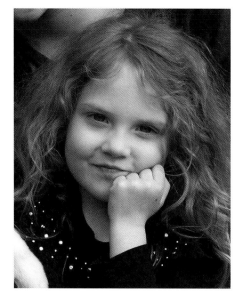

**Reference Photo**

### 1 Proportion and Sketch the Shape of the Head

Using a 2B pencil (or medium gray pastel pencil if working directly on the drawing paper), sketch an angled line for the center of the face. Proportion the top, bottom and sides of the head, then follow the proportion lines for the shape of the face.

 **Place the Features**
Sketch angled lines to place the eyes, nose and mouth.

**Place the Brows, Lips and Hair**
Sketch lines to place the brows, lips and the shape of the hair.

**Establish the Width of the Facial Features and Place the Collar**
Sketch lines for the width of the eyes, nose and mouth. Sketch a curved line for the shirt collar.

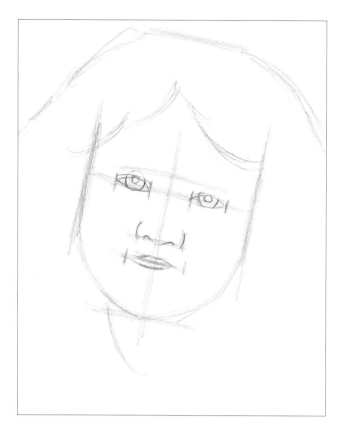

 **Define the Facial Features**
Define the eyes, nose and mouth.

 **Sketch the Hand and Arm**
Sketch the basic shape of the hand, paying attention to its size and placement in relation to the face. Add two lines for the arm.

**Define the Hand**
Sketch the fingers and thumb to define the hand.

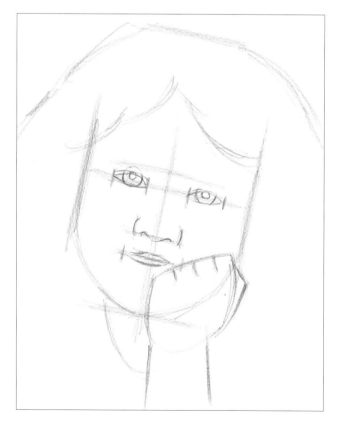

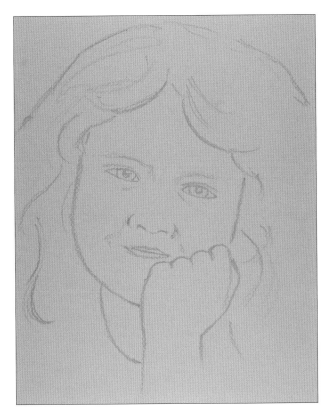

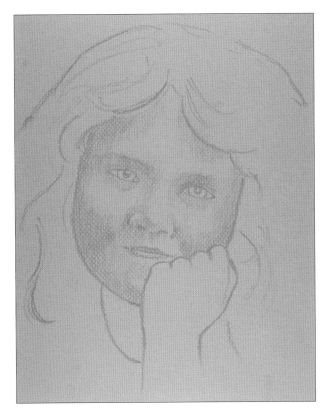

 **Add Details and Erase Unwanted Lines or Trace or Transfer the Image**
Add details, including hair. Erase unwanted lines if working directly on the drawing paper, or trace or transfer the image onto drawing paper using a medium gray pastel pencil.

**Start Shading the Face**
Start adding values to the face with a medium gray pastel pencil, which is darker than the paper.

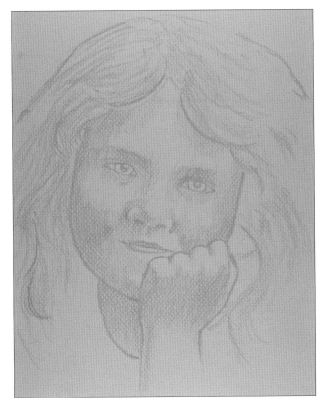

**Add Shading to the Hair, Hand, Arm and Neck**
Continue adding values to the hair, hand, arm and neck. The paper provides the value for many areas throughout the portrait, so it isn't necessary to go heavy with the pastel pencil.

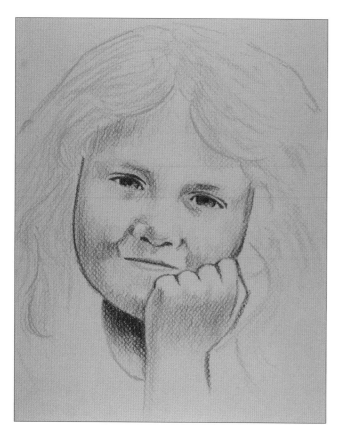

**11** Add Dark Values to the Face, Hand and Arm
With the black pastel pencil, add darks to the face, hand, arm and neck.

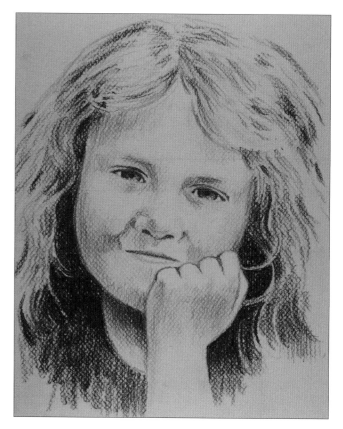

**12** Add Dark Values to the Hair and Shirt
Darken the hair and shirt with the black pastel pencil.

**13** Add Lighter Values
With the light gray pastel pencil, add lighter values to the face, hand, arm and hair.

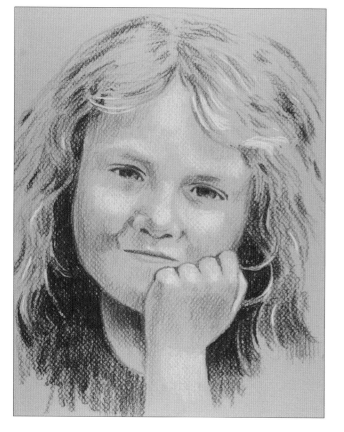

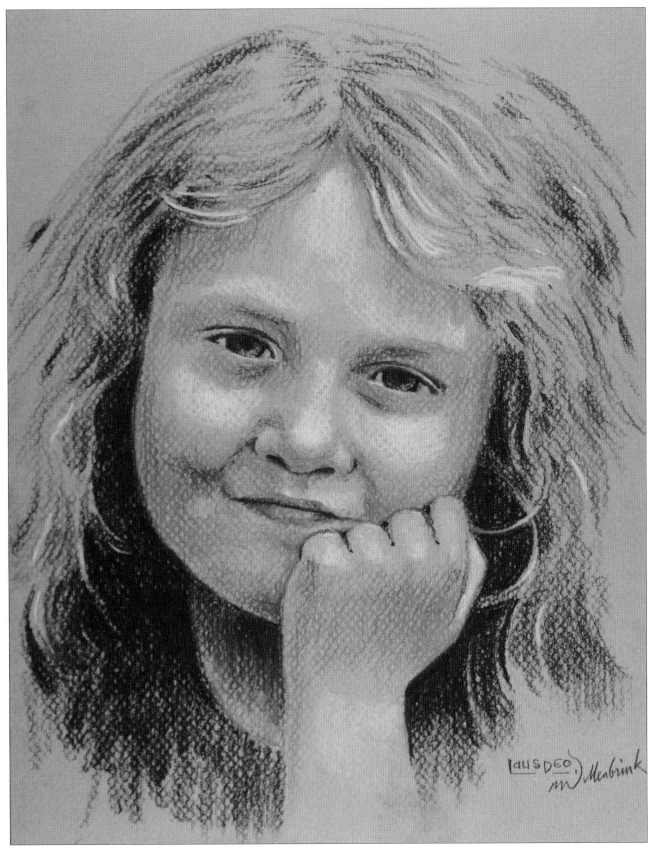

14 **Make Adjustments and Add Details**
With the light gray, medium gray and black pastel pencils, lighten or darken, adding details as needed to complete the portrait. Sign and date your portrait.

**Little Princess**
Pastel pencil on gray drawing paper
12" × 9" (30cm × 23cm)

# Self-Portrait in Profile

This demonstration is a self-portrait of me, Mark Willenbrink. You can draw this portrait of me, or you can work from a photo of yourself, following the same steps. To take a photo of yourself, it is best to use a camera supported with a tripod, then use a remote shutter release. Many digital cameras can be set to take black-and-white photos, which are easier to work from than color photos when doing monochromatic (one color) art because there is less guesswork when translating the values. A plain sheet can be used as a backdrop for the background.

The primary light source of my photo is from the right, causing the right side of the face and hand to receive more light than other areas.

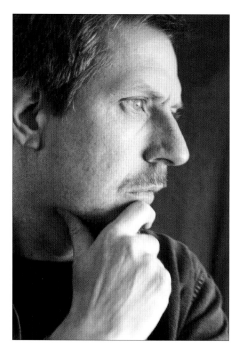

**Reference Photo**

## Materials

**Paper**
12" × 9" (30cm × 23cm) medium-tooth drawing paper

**Pencils**
2B graphite pencil
4B graphite pencil
8B graphite pencil

**Other Supplies**
kneaded eraser

**Optional Supplies**
12" × 9" (30cm × 23cm) sketch paper
lightbox or transfer paper

- Hands
- Light Effects
- Hair and Facial Hair
- Ears
- Eyes

**1** Sketch Placement Lines
With a 2B pencil, sketch a curved line for the basic form of the right side of the face. Sketch lines for the eyes, nose, brows and mouth. Add a line for the chin, placing it the same distance from the nose as the nose is from the brows. Though the hand covers the chin, sketching the chin will help place the hand and shadows.

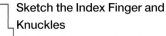

2 **Place the Eye, Nose and Ear**
Sketch two short vertical lines along the previously drawn line to place the eye. Sketch a diagonal line and a short vertical line to place the nose. Add two vertical lines between the previously drawn brow and nose lines to place the ear.

3 **Form the Facial Features**
Form the eye, brow, nose, lips, ear, hair, chin and jawline.

4 **Sketch the Index Finger and Knuckles**
Start sketching the hand, beginning with lines for the index finger, which rests below the lower lip. Draw a line to place the knuckles.

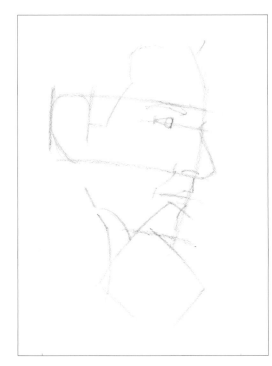

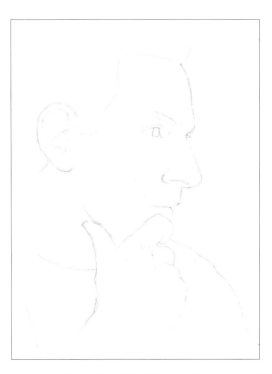

5 **Sketch the Overall Hand Shape**
Sketch a rectangle for the back of the hand. Notice its size in relation to the face. Add two curved lines for the thumb, paying attention to their placement in relation to the jawline.

6 **Add the Shoulder, Shirt and Details, and Transfer Image or Erase Unwanted Lines**
Sketch the shoulder and shirt. Add details to the face and hand, and refine the creases and shadow lines. Erase unwanted lines if you are working directly on drawing paper. Otherwise, trace or transfer the structural sketch onto drawing paper with the 2B pencil.

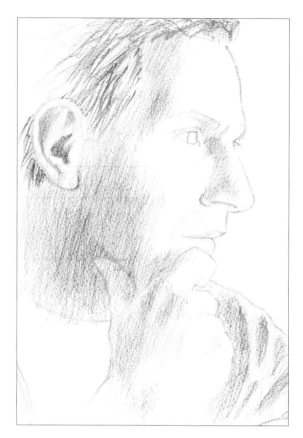

 **Start Adding Values**
With a 4B pencil, start adding values, keeping the areas white that receive the most light.

 **Add Middle Values**
Continue adding middle values in many places, building upon the lighter values previously laid down.

 **Add Darks**
With the 8B pencil, add the dark values including the hair, shirt, background and shadows on the jaw.

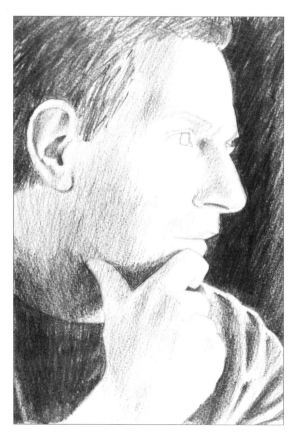

## Test Your Portrait

Once you have completed a demonstration, you may look at your portrait and think that something just isn't right. Many times a good portrait is one step away from a great portrait. You can improve your work just by making simple adjustments and pushing contrasts. Place a sheet of tracing paper over a portrait drawing to test darkening areas of a subject.

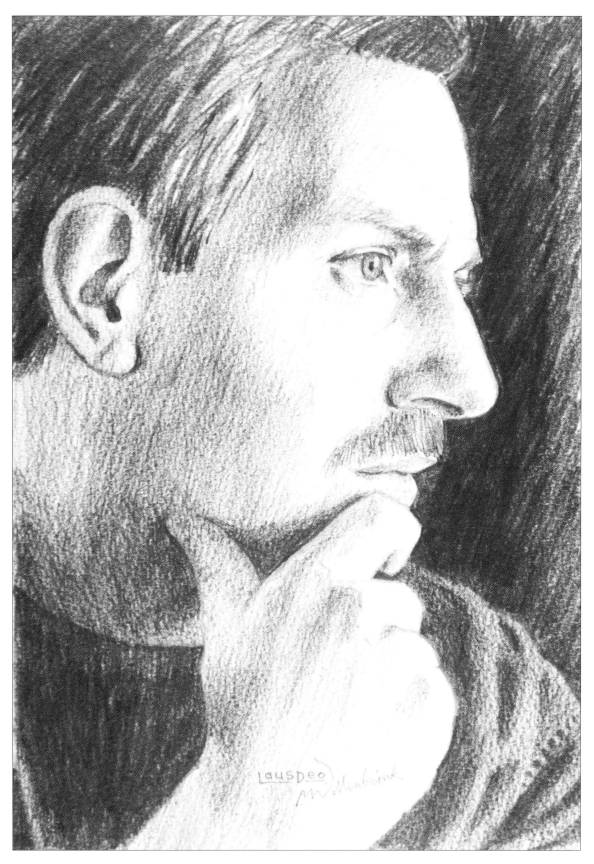

## 10 Finish With Details and Adjustments

Add details to the eyes and adjust some of the lights and darks. To make an area lighter, just pinch the kneaded eraser and dab to lift out some of the graphite in that area. Sign and date your portrait.

**Self-Portrait**
Graphite pencil on drawing paper
12" × 9" (30cm × 23cm)

# Toddler With Toy Phone

To help simplify the process of drawing this portrait, think of the structural sketch as three elements placed together: the head and torso, the telephone, and the hands and arms. To make the portrait look believable, it's important to get these elements proportioned and positioned accurately.

The light is coming from the left, causing the right side of the subject to be darker.

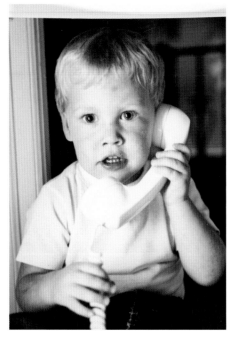

**Reference Photo**

## Materials

**Paper**
12" × 9" (30cm × 23cm) medium-tooth drawing paper

**Pencils**
2B graphite pencil
4B graphite pencil
6B graphite pencil

**Other Supplies**
kneaded eraser

**Optional Supplies**
12" × 9" (30cm × 23cm) sketch paper
lightbox or transfer paper

• Hands
• Props
• Child Proportions
• Teeth
• Eyes
• Hair

**1 Proportion and Sketch the Shape of the Head**
Use a 2B pencil to proportion the top, bottom and sides of the head. Follow the proportion lines to form the shape of the head. Notice how the top of the head is wider than the lower portion of the head.

**Place the Eyes, Nose, Mouth and Center of the Face**
Continuing with the 2B pencil, sketch slightly angled horizontal lines to place the eyes, nose and mouth. Sketch a slightly angled vertical line for the center of the face.

**Sketch Placement Lines for the Brows, Lips and Ear**
Sketch more lines for the placement of the brows, lips and ear.

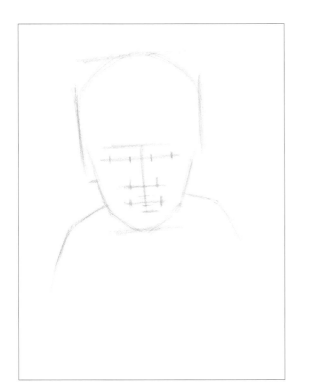

**Sketch Lines for the Width of the Facial Features and for the Shoulders**
Indicate the width of the eyes, nose and mouth with short vertical lines. Sketch lines for the shoulders.

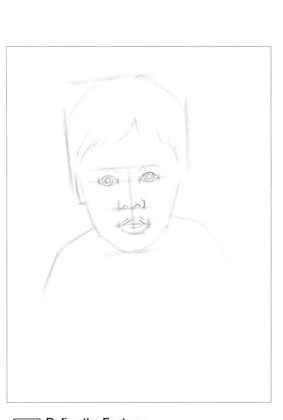

**Define the Features**
Add definition to the features, including the hair, brows, nose, mouth and ear.

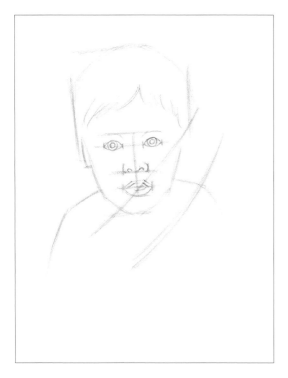

**6** Sketch the Telephone

Start sketching the shape of the phone, making the long curved lines of the handle and a similar line connecting the receiver and mouthpiece. Make sure these lines are in the correct position to the face.

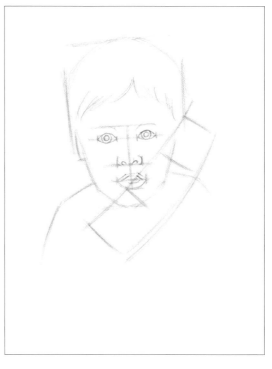

**7** Sketch the Ends of the Telephone

Sketch lines for the receiver and mouthpiece of the phone.

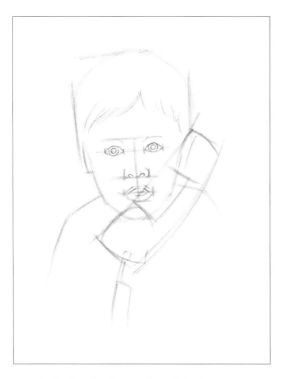

**8** Define the Form of the Telephone

Define the curved forms of the phone including the cord.

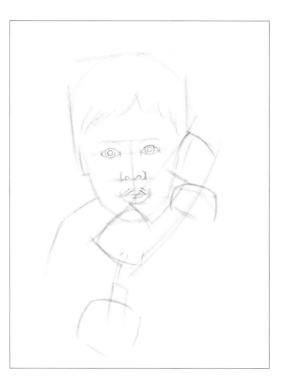

**9** Sketch the Hands

Sketch the hands with basic mitten shapes for the fingers in contact with the telephone handle and cord.

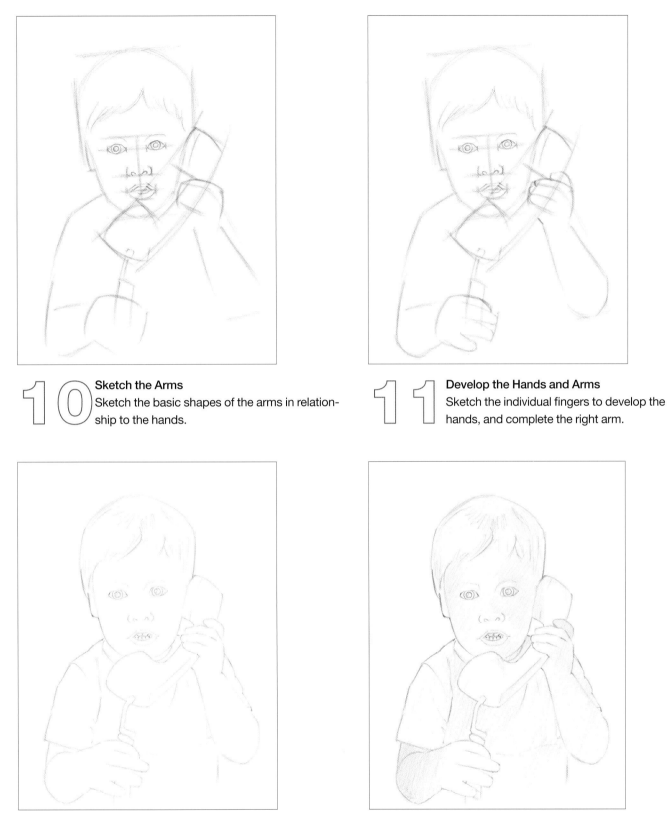

**10** Sketch the Arms
Sketch the basic shapes of the arms in relationship to the hands.

**11** Develop the Hands and Arms
Sketch the individual fingers to develop the hands, and complete the right arm.

**12** Add Details and Erase Unwanted Lines or Trace or Transfer the Image
Add details including the hair, teeth and shirt. If working directly on the drawing paper, erase unwanted lines. Otherwise, trace or transfer the image onto drawing paper using the 2B pencil.

**13** Start Shading With Lighter Values
With a 2B pencil, start shading the lighter areas of the subject. Most of the phone handle can be kept white. The darker form of the shirt will distinguish it from the shape of the phone.

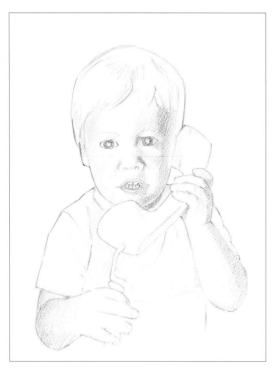

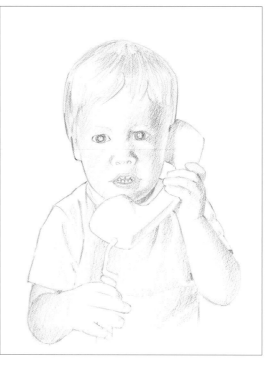

**14** Add Middle Values to the Face, Hands and Arms
With a 4B pencil, add middle values to the face. Most of the light is coming from the upper left with some reflected light on the right side of the face. Add middle values to the hands and arms.

**15** Add More Middle Values
Continue adding middle values to the hair, phone and shirt.

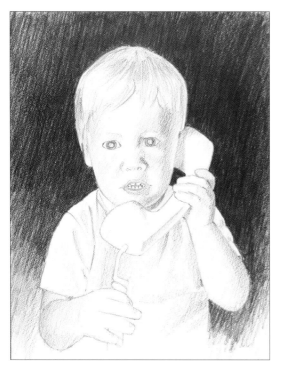

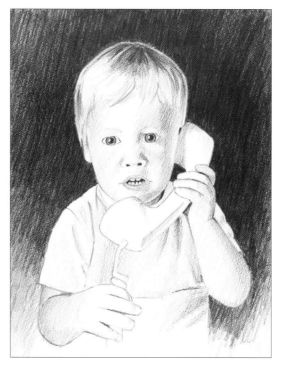

**16** Add Darks to the Background
With the 6B pencil, add dark values to the background. Notice that the darkest areas are toward the top around the head.

**17** Add Darks to the Subject
With 4B and 6B pencils, add darks to the hair, eyes, nose, mouth and fingers of the subject.

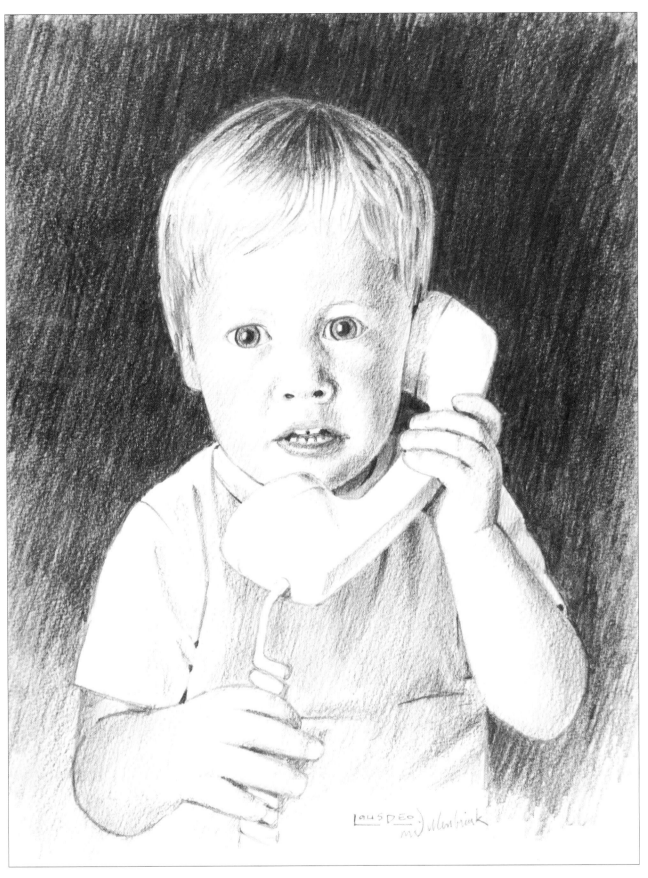

**18** **Make Adjustments and Add Details**
Adjust by erasing and darkening different places, and add details. Sign and date your portrait.

**J.T.**
Graphite pencil on drawing paper
12" × 9" (30cm × 23cm)

# Finishing Your Portraits

Now it's time to prepare your portraits for display. Framing your portraits may not seem important now, but once you have completed these steps, you will see your portraits in a whole new light. They will have a more finished, professional look that will make you proud of your masterpieces.

## Using a Fixative

You may choose to spray a fixative on your drawings, particularly artwork done with charcoal or pastel, which is more prone to smearing over time. Before spraying your artwork, check to see that it is free of dust and other particles. Be sure to follow the instructions on the spray can, and use only in a well-ventilated area.

## All Dressed Up

Frames and mats should complement the art and express the general theme without distracting from the art itself. Some artists include a nameplate on the front of the frame that states the title of the art piece as well as their name. The back may be covered with a sheet of craft paper, which acts as a dust cover. Bumpers keep the frame from resting directly against a wall and allow air to circulate around the painting to prevent mold. You may also want to place a sticker stating the artist's information on the back.

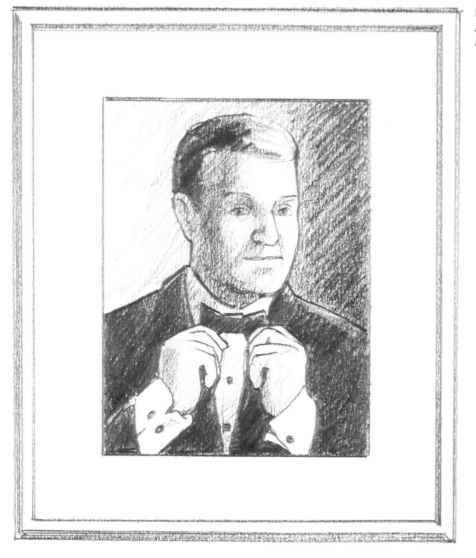

**Dressed for Success**
An attractive mat and frame enhance a drawing and give it a finished look.

# Conclusion

This book is only the beginning. You may want to revisit some of your favorite demonstrations to hone your skills and develop your own artistic style.

Take your time and be patient with yourself. Look at your previous artwork to see the progress you've made. Drawing portraits is a skill that gets better with practice.

The knowledge and expertise gained through drawing portraits can be applied to painting portraits in other mediums. Our other *Absolute Beginner* books are great resources for learning new subjects and mediums as you continue on your artistic journey.

Have fun and keep up the good work!

Mark and Mary Willenbrink

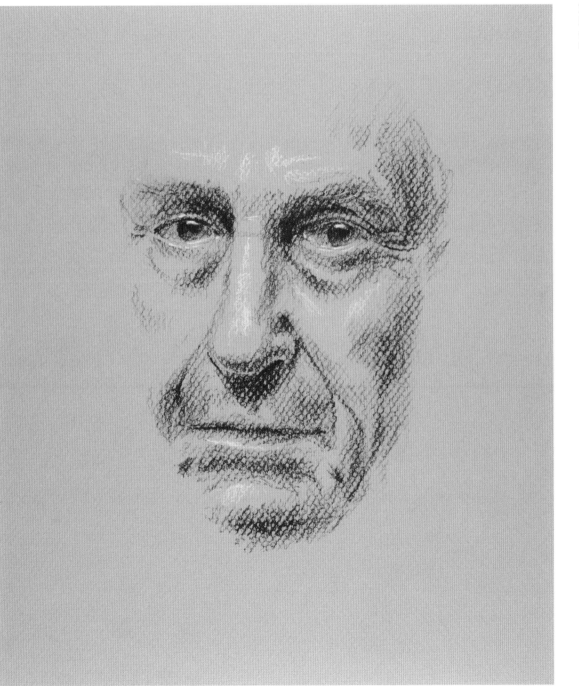

**Portrait Study**
Pastel pencil on gray drawing paper
9" × 6" (23cm × 15cm)

# Glossary

## A

**Art horse:** (or drawing horse, horse bench) a bench used for sketching and drawing with a prop for a drawing board.

## B

**Black-and-white drawing:** also called chiaroscuro, a drawing that defines the subject using highly contrasting values.

**Blending stump:** also referred to as a tortillion, a roll of tightly wound soft paper, about the size of a pencil, used for blending.

**Blind contour sketch:** a contour sketch created without the artist looking at the art in progress.

## C

**Carbon pencil:** a pencil with a carbon core.

**Caricature:** a drawing that has distorted the features of the subject.

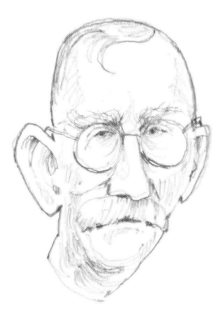

**Cast shadow:** a shadow cast onto another form.

**Charcoal pencil:** a pencil with a charcoal core.

**Charcoal stick:** a stick made of charcoal with no outer casing.

**Chiaroscuro:** also referred to in this book as black-and-white drawing, a drawing defined by highly contrasting values.

**Colored pencil:** a pencil with a colored core but also available in black, white and grays.

**Continuous line sketch/drawing:** see contour sketch/drawing.

**Contour sketch/drawing:** also referred to as a continuous line drawing, a sketch or drawing that is done by keeping the pencil in contact with the paper and moving the pencil along the surface, while studying the contours of the subject.

**Contrast:** differing values.

**Copier paper:** inexpensive paper used in copy machines or printers.

**Crosshatching:** lines overlapping in different directions.

## D

**Divider:** a tool similar in appearance to a circle compass used for measuring and proportioning.

**Drawing:** a finished representation of a subject.

**Drawing board:** a sturdy board with a smooth surface used as a support for sketching and drawing paper.

**Drawing paper:** heavyweight paper used for drawing, usually 80 to 90 lbs. (170gsm to 190gsm) or more.

## E

**Erasing shield:** a thin metal shield used to mask areas during erasing.

## F

**Fixative:** a spray applied to dry artwork to prevent smearing.

**Form shadow:** a shadow on a subject that displays its form.

**Frisket:** a sheet of paper used to cover part of a drawing to control the placement of the pencil strokes.

## G

**Graphite pencil:** a pencil with a graphite core.

**Graphite stick:** a stick made of graphite with no outer casing.

## H

**Highlights:** the lightest, brightest areas of a subject.

## K

**Kneaded eraser:** a soft, puttylike eraser.

## L

**Lead:** common reference to the core of a pencil.

**Lead holder:** a type of mechanical pencil that can accommodate thicker graphite than other mechanical pencils.

**Lightbox:** a shallow box with a light inside and a translucent surface that is used to trace artwork.

**Light source:** the origin of light in a composition.

# M

**Mechanical pencil:** a pencil that allows for refillable graphite.

# P

**Pad:** a stack of sheets of paper that is attached at one side.

**Pastel pencil:** a pencil with a pastel chalk core.

**Pencil extender:** a pencil handle with a sleeve to hold pencils that would otherwise be too short to hold.

**Pencil sharpener:** a device used to form the end of a pencil to a point.

**Proportion lines:** lines used to obtain the correct proportions when drawing.

# R

**Reference photo:** a photo used to study a subject.

**Reflected light:** light that is reflected from one surface onto another.

**Rotary lead pointer:** a device used to sharpen the graphite of a lead holder.

# S

**Sandpaper pad:** a small pad of sandpaper used to sharpen the core of a pencil.

**Sewing gauge:** a tool with a movable guide that can be used for measuring and proportioning.

**Sketch:** a rough, unfinished representation of a subject.

**Sketch paper:** lightweight paper used for sketching, commonly 50 to 70 lbs. (105gsm to 150gsm).

**Slip sheet:** a sheet of paper placed over a portion of a drawing so the hand can be placed on top without smearing the drawing.

**Structural sketch:** a sketch of a subject showing the basic structural form without values.

# T

**Tooth:** the roughness of a paper's surface.

**Tracing paper:** thin, translucent paper used for tracing.

**Transfer paper:** also referred to as graphite paper, a graphite-coated paper used for transferring a structural sketch onto drawing paper.

# V

**Value scale:** a cardboard or paper strip that shows a range of values from black to white.

**Value sketch:** a sketch that displays the lights and darks of a subject.

**Values:** the lights and darks of a subject.

# W

**White vinyl eraser:** a soft, nonabrasive eraser.

**Woodless pencil:** a pencil made of a cylinder of graphite coated with lacquer.

# Index

**Profile Study**
Graphite pencil on drawing paper
6" × 4" (15cm × 10cm)

Other fine North Light Books are available from your
favorite bookstore, art supply store or online supplier. Visit
our website at www.fwmedia.com.

16   15   14   13   12      5   4   3   2   1

DISTRIBUTED IN CANADA BY FRASER DIRECT
100 Armstrong Avenue
Georgetown, ON, Canada  L7G 5S4
Tel:  (905) 877-4411

DISTRIBUTED IN THE U.K. AND EUROPE
BY F&W MEDIA INTERNATIONAL LTD
Brunel House, Forde Close, Newton Abbot, TQ12 4PU, UK
Tel: (+44) 1626 323200, Fax: (+44) 1626 323319
Email: enquiries@fwmedia.com

DISTRIBUTED IN AUSTRALIA BY CAPRICORN LINK
P.O. Box 704, S. Windsor NSW, 2756 Australia
Tel:  (02) 4577-3555

Edited by Mary Burzlaff Bostic
Designed by Laura Spencer
Production coordinated by Mark Griffin

# About the Authors

Mark and Mary Willenbrink are the best-selling authors of the
*Absolute Beginner* series. Mark is also a fine artist and teaches
art classes and workshops. His website is www.shadowblaze.
com. Mark and Mary live in Cincinnati, Ohio, with their three
children, two cats and border collie.

# Acknowledgments

First, we want to thank all of the individuals who allowed their
portraits to be used. You made this book unique!

A special thanks to all those at F+W Media, Inc. who worked
behind the scenes for us to make this another outstanding *Abso-
lute Beginner* book: Laura Spencer, designer; Mark Griffin, pro-
duction coordinator; Kirstie Runion, editorial intern; Nicole Miller,
publicist; and Stefanie Laufersweiler, freelance content editor.

Mary Bostic, we thank you for all you do as our editor. Again,
you made everything go so smoothly. You are a gift to us!

Throughout the writing of this book, our friends and family
constantly showed their love and support. And as a husband
and wife team, we express to each other how much we enjoy
working together and appreciate each other, but it is nice to do it
in writing.

Lastly, we thank the Lord for His inspiration. We believe He is
the author of our individuality.

## Metric Conversion Chart

| To convert | to | multiply by |
| --- | --- | --- |
| Inches | Centimeters | 2.54 |
| Centimeters | Inches | 0.4 |
| Feet | Centimeters | 30.5 |
| Centimeters | Feet | 0.03 |
| Yards | Meters | 0.9 |
| Meters | Yards | 1.1 |

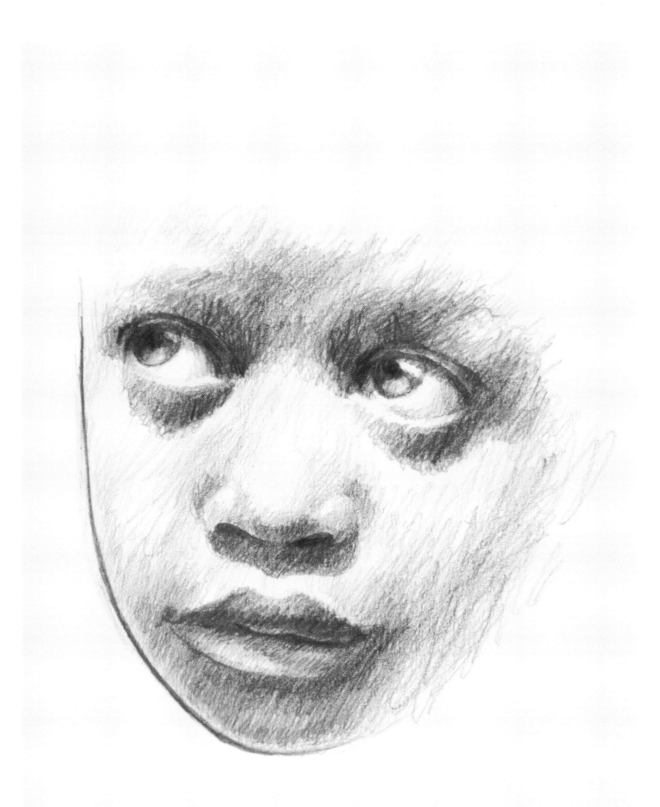

# Dedication

Laus Deo

Praise to God

We dedicate this book to our children. Thank you for your willingness to be a part of the development of this project. Your contributions have made this a great book!

**Eyes of Innocence**
Graphite pencil on drawing paper
7" × 7" (18cm × 18cm)

# Ideas. Instruction. Inspiration.

Receive FREE downloadable bonus materials when you sign up for our free newsletter at artistsnetwork.com/Newsletter_Thanks.

Scan this code with your phone to go directly to the bonus materials webpage.

**Find the latest issues of The Artist's Magazine on newsstands, or visit artistsnetwork.com.**

These and other fine North Light products are available at your favorite art & craft retailer, bookstore or online supplier. Visit our websites at artistsnetwork.com and artistsnetwork.tv.

Follow North Light Books for the latest news, free wallpapers, free demos and chances to win FREE BOOKS!

Visit artistsnetwork.com and get Jen's North Light Picks!

Get free step-by-step demonstrations along with reviews of the latest books, videos and downloads from Jennifer Lepore, Senior Editor and Online Education Manager at North Light Books.

Follow us!